The Campus History Series

University of
PENNSYLVANIA

Amey A. Hutchins
with the University of Pennsylvania Archives

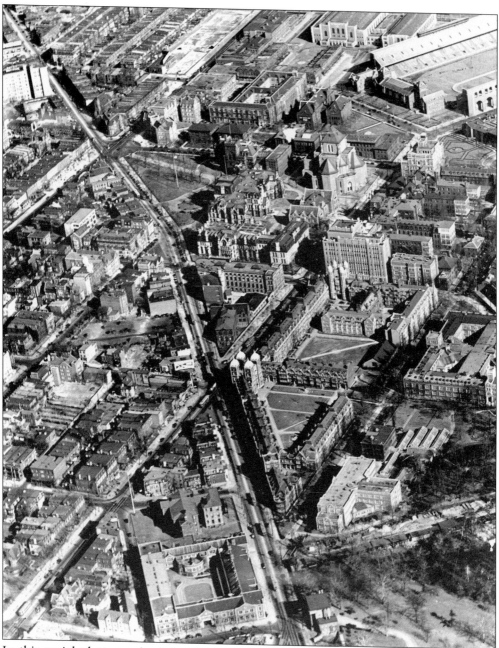

In this aerial photograph of the University of Pennsylvania, taken *c.* 1930, Woodland Avenue is the main street that slants down from the upper left toward the lower right. From top to bottom, starting in the upper right corner, are the Palestra and Hutchinson Gymnasium, Franklin Field, Irvine Auditorium, Houston Hall, the Hospital of the University of Pennsylvania, the Quad, and the School of Veterinary Medicine. The University Library and College Hall are to the left of Irvine Auditorium and Houston Hall.

The Campus History Series

UNIVERSITY OF
PENNSYLVANIA

AMEY A. HUTCHINS
WITH THE UNIVERSITY OF PENNSYLVANIA ARCHIVES

ARCADIA

First published 2004
Reprinted 2004

Published by Arcadia Publishing,
Charleston SC, Chicago IL, Portsmouth NH, San Francisco CA

Printed in Great Britain

Library of Congress Catalog Card Number: 2003116602

For all general information, contact Arcadia Publishing:
Telephone 843-853-2070
Fax 843-853-0044
E-mail sales@arcadiapublishing.com
For customer service and orders:
Toll-free 1-888-313-2665

Visit us on the Internet at www.arcadiapublishing.com

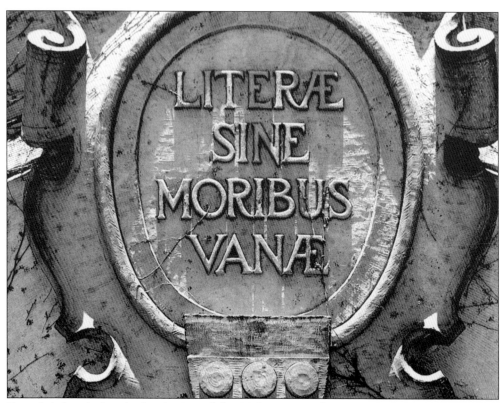

For a brief period at the beginning of the 20th century, the university changed its motto to *Literae sine moribus vanae,* "Learning without morals is empty," and it was thus carved into the ornamentation of the Quad. Since 1755, however, the motto has generally been *Leges sine moribus vanae,* "Laws without morals are empty," which continues to appear on the university arms into the 21st century.

CONTENTS

ACKNOWLEDGMENTS

The following people deserve thanks for making this book possible: William H. Rau, William M. Rittase, Frank Ross, Jules Schick, and Lawrence S. Williams, photographers who documented life at Penn over the decades; George E. Nitzsche, Leonidas Dodson, and Francis James Dallett, past archivists who preserved the collections of the University of Pennsylvania Archives for future research; Erin Loftus, the editor at Arcadia Publishing who guided the book from proposal onward; Mark Frazier Lloyd, director of the University Archives and Records Center, who secured funding for the book and chaired the advisory committee; Michel T. Huber, Jennifer Rizzi, Nancy M. Shawcross, and Sandy Smith, advisory committee members who improved the proposal and each chapter; and J. Curtiss Ayers, Kaiyi Chen, J. M. Duffin, DiAnna L. Hemsath, Mary D. McConaghy, Andy Ross, and Theresa R. Snyder, past and present colleagues at the University of Pennsylvania Archives who provided moral, technical, and historical support.

INTRODUCTION

The early history of the University of Pennsylvania is marked on one hand by the guiding inspiration and practical assistance of Benjamin Franklin and on the other by a succession of predecessor institutions and changes in leadership. In 1755, the College, Academy, and Charitable School of Philadelphia received a charter from the colony and assumed the power to grant undergraduate degrees. It was first called the University of Pennsylvania in 1791, when, after surviving the American Revolution and subsequent state takeover, the university reclaimed its identity as a private institution (as it has been ever since). Its identity as the first university in the United States dates to 1765, when it established the first medical school in the colonies.

With the new century, the university shifted to a new campus. In 1800, Penn purchased a mansion that had been built to be the residence of the president of the United States. "The President's House" was the university's home for nearly 30 years. In 1829, the Departments of Arts and Medicine moved into twin buildings built where the President's House had stood. In 1850, Penn created the University of Pennsylvania Law School, which was followed by the School of Engineering two years later. In 1872, the university moved again to open land west of the Schuylkill River, which remains its home today. At first, all university departments and functions were housed in College Hall, but Penn began to grow rapidly. Before the end of the century, the Towne Scientific School, the School of Dental Medicine, the Wharton School of Finance and Commerce, the Graduate School of Arts and Sciences, and the School of Veterinary Medicine had all been established.

During this time of change and expansion, the university's definition of its student body was also expanding. In the late 1870s, a few exceptional women began to attend classes leading to certificates of proficiency and graduate degrees. In the 1880s, pioneering African American men began earning degrees in first professional and then undergraduate programs. As the 19th century ended, the university's relationship to all its students was changing with the development of athletic programs, the opening of the first student union in America, and the construction of dormitories.

In the 20th century, Penn continued to adapt itself to changing academic, professional, and social contexts. The School of Education, the School of Social Work, the School of Design, the Moore School of Electrical Engineering, the College of Liberal Arts for Women, the School of Nursing, and the Annenberg School of Communications were in place by 1959. Fifteen years later, the College, the College for Women, and the Graduate School of Arts and Sciences were combined under the Faculty of Arts and Sciences, at which point undergraduate programs at Penn became fully coeducational. In 1993, the university elected Judith Seitz Rodin, an alumna of Penn's College for Women, to its presidency. With her election, Penn became the first Ivy League institution to have a woman as president and signaled its intention to continue breaking new ground as the 21st century approached.

One

BRICKS AND MORTAR

DEVELOPMENT OF THE CAMPUS

It is propos'd . . . That a House be provided for the Academy,
if not in the Town, not many miles from it;
the Situation high and dry, and if it may be, not far from a River,
having a Garden, Orchard, Meadow, and a Field or two.

—Benjamin Franklin, 1749

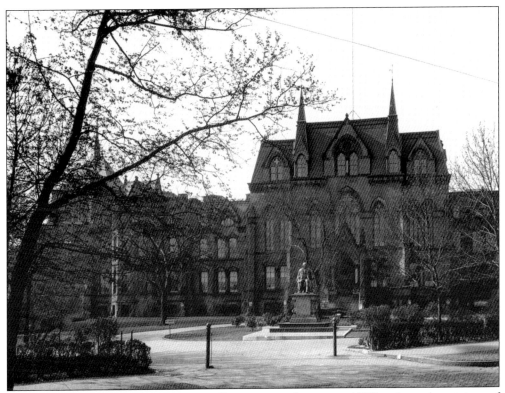

This photograph shows College Hall sometime between 1939, when the statue of Benjamin Franklin was moved to campus and dedicated, and 1958, when Woodland Avenue was closed. The statue, which previously stood at the corner of Ninth and Chestnut Streets, has become one of the most famous Penn landmarks.

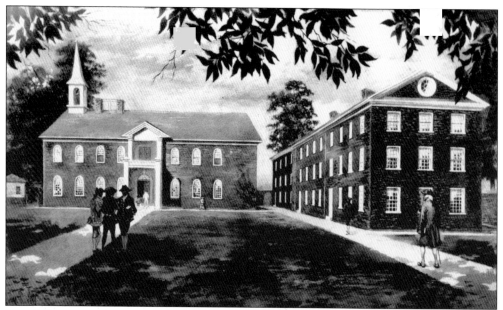

Penn's first campus was in the Old City neighborhood of today's Philadelphia, at Fourth and Arch Streets. This 1913 watercolor by Charles Lefferts was based on an 18th-century drawing by Pierre Eugène Du Simitière. It shows the Academy of Philadelphia on the left, which was purchased and converted for school use in 1750. The building on the right is a dormitory that was built in 1762.

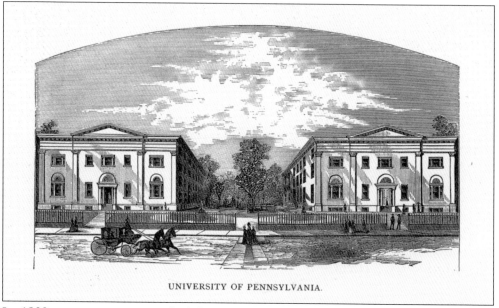

UNIVERSITY OF PENNSYLVANIA.

In 1829, cornerstones were laid for new buildings to house the College (arts and sciences) and the Medical Department on the university's land on Ninth Street, between Market and Chestnut. The buildings were designed by William Strickland, who also designed the Second Bank of the United States in Philadelphia. The new buildings, shown here in an image from 1830, were Penn's home until the move to West Philadelphia in 1872.

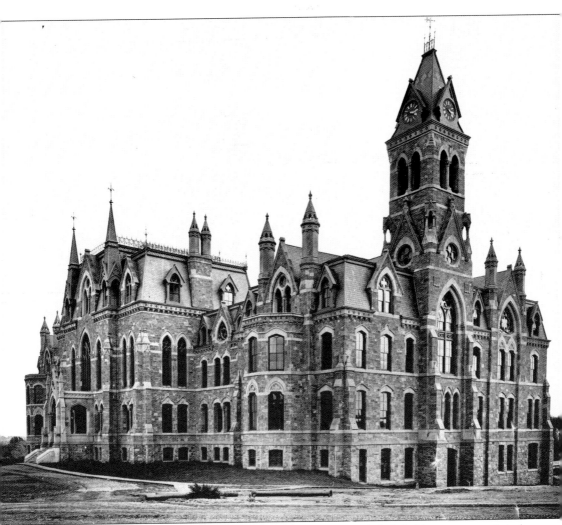

College Hall, the first building of the new campus in West Philadelphia, was completed in 1872. The architect, Thomas Richards, was first an instructor and then, for 17 years, a professor of architecture. College Hall held all of Penn's classrooms and its library. This *c.* 1874 photograph shows how the university found abundant space by crossing the Schuylkill River. Even so, from the end of the Civil War onward, West Philadelphia became increasingly connected to central Philadelphia through developments such as new bridges across the Schuylkill and horse-car lines. This photograph also shows one of the towers that originally marked the two ends of College Hall. This tower, at the west end of the building, was dismantled in 1914; its partner at the east end of the building was taken down in 1929.

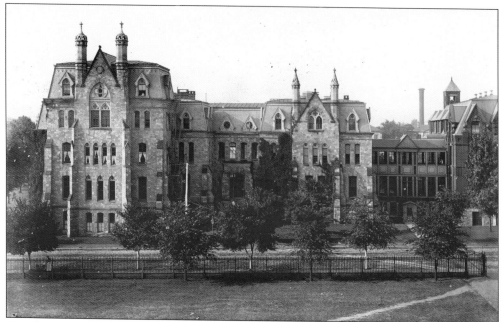

The Hospital of the University of Pennsylvania, located across Spruce Street from the future site of Houston Hall, opened in 1874. It was one of the earliest university-affiliated hospitals in the country. The 1874–1875 *Catalogue* proclaimed, "The immediate neighborhood of the University to its own Hospital . . . forms another and quite peculiar advantage of this Institution." This photograph is from 1888.

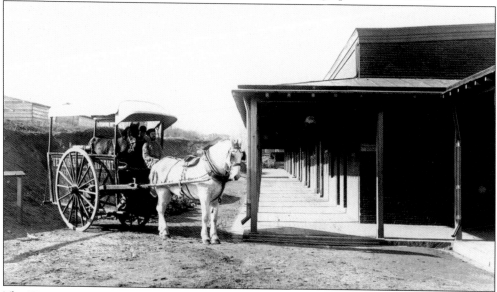

The Veterinary Department opened in 1884 on the 3600 block of Pine Street, which today is Hamilton Walk in the School of Medicine complex. Rush Huidekoper, the first dean of the faculty, reported to the provost in October that the amphitheater, dissecting room, blacksmith's shop, and laboratories were complete and serving more than 20 students in the first entering class. This photograph, taken *c.* 1900, shows one of the department's two ambulances.

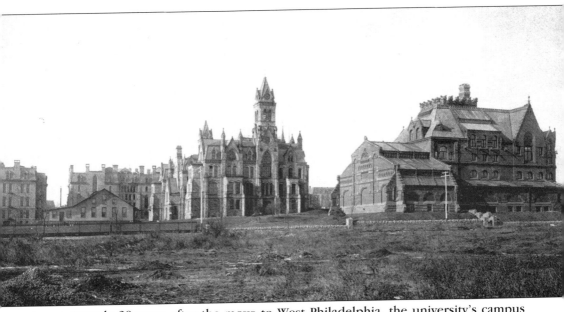

Approximately 20 years after the move to West Philadelphia, the university's campus had expanded to 40 acres, encompassing several buildings. This c. 1892 photograph depicts the buildings in the center of campus. From left to right, they are the Medical and Dental Laboratory (later called the Robert Hare Laboratory of Chemistry, on the site of today's Williams Hall), a dining hall, Medical Hall (today's Logan Hall), College Hall, and the newest addition at the time of this photograph, the University Library, completed in 1891. The hospital, south of Spruce, and the Veterinary Department and Hospital, south of Pine, do not appear in this view. The Department of Law's offices, lecture rooms, and library were across the Schuylkill River in Center City, "in convenient proximity to the Court Rooms and offices of the Bar."

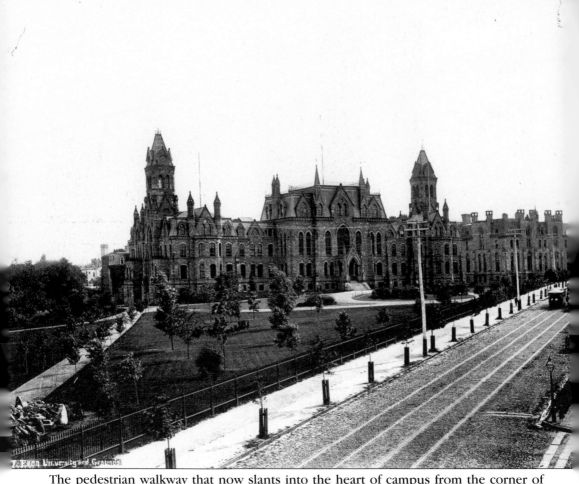

The pedestrian walkway that now slants into the heart of campus from the corner of 34th and Walnut was once part of Woodland Avenue, a busy street running past College Hall and Logan Hall. Woodland was the northern boundary of the campus for nearly 30 years. Two items in this 1892 photograph unfamiliar to modern students are the iron railing that runs along Woodland and the pile of rocks partially visible in the lower left corner. The iron railing surrounded Rittenhouse Square, a Philadelphia park, until 1884, when the university purchased it for $3,500 and used it to mark the perimeter of the College grounds. The rocks are part of a display of local geological specimens constructed in 1881 by Eli K. Price, trustee of the university and vice president of the American Philosophical Society.

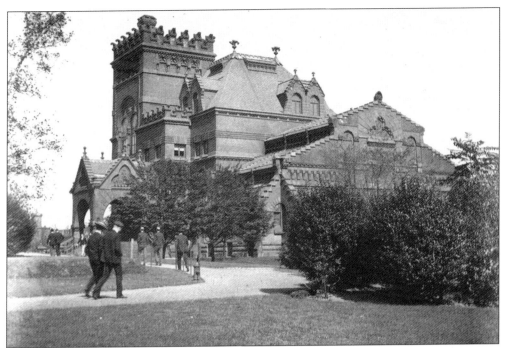

The Fisher Fine Arts Library was once the library for the whole university. It opened in 1891 with an original capacity of 100,000 volumes (the Penn library system celebrated its five-millionth acquisition in 2001). The library was open from 8:30 to 5:30 but was closed on Sundays and holidays. Students and faculty could take out books, and the public had "free use of the Library for consultation."

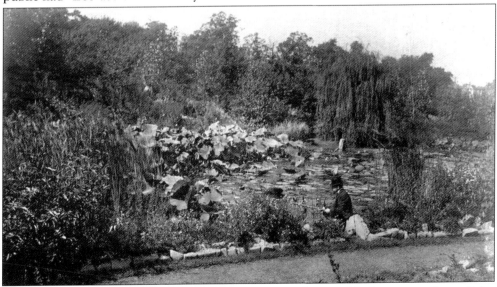

The botanical gardens south of Hamilton Walk were designed by botany professor John Macfarlane in 1894. In 1940, Cornell Dowlin noted in *The University of Pennsylvania Today,* "The lily pond in the center, usually called the 'frog pond,' once served as a place to duck freshmen, but happily the practice has been ended to prevent damage—to the flora, not the fauna."

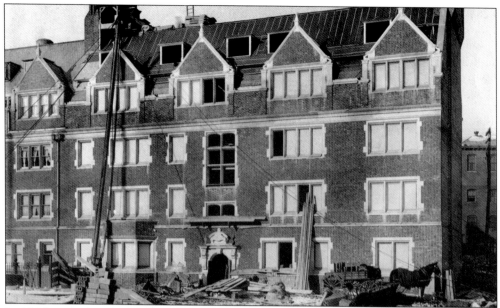

In 1894, Penn began to construct the dormitories of the Quad, an effort that proceeded rapidly until the Great Depression. The above photograph shows one of the houses under construction in 1905, while the below photograph shows the Quad in 1912. The second campus never had dormitories, and the West Philadelphia campus had none for its first 20 years. The university committee championing this innovation made its case: "We need them for the student's welfare in economy, in hygiene, in comfort, in morals; but most of all that he may find in Alma Mater's precincts, a home and a brotherhood to supply that in his education, which no learning of Professors and no wealth of laboratories and libraries and museums can possibly furnish."

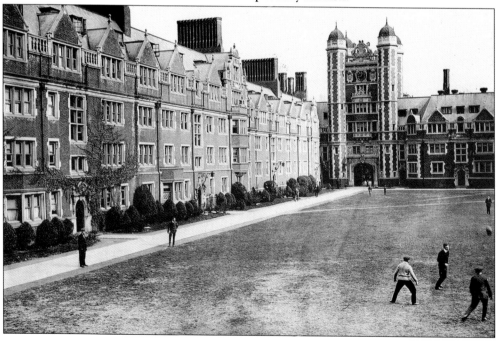

The architectural firm Cope & Stewardson, led by two architecture faculty members, designed the first Quad dormitories. The firm looked to Oxford and Cambridge for inspiration, even going so far as to send a member of its team to England to study the dormitories there. One nod to the tradition in which the Penn dormitories were built was the use of gargoyles as decorative elements throughout the Quad.

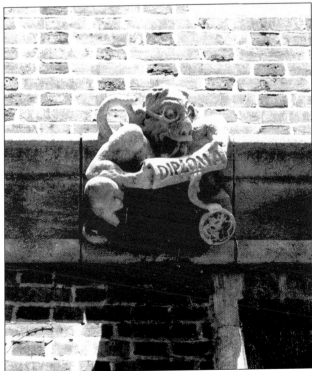

The gargoyles were designed by a former student from Penn's architecture program, John Joseph Borie, who joined Cope & Stewardson. The fact that a former student custom designed these figures for Penn no doubt helps to explain the bookish themes that characterize many of them. The person who executed Borie's designs was likely John Maene, a well-respected local carver who also did work at Wellesley College and Princeton University.

Houston Hall, shown here in 1903, opened in 1896 as the first student union in the country. The Houston Club's constitution stated, "The object of this Club shall be to draw together students, officers and alumni of all Departments of the University in a wholesome social life." The club offered a swimming pool, library, and bowling alley. There were also billiard tables, but card games and women were not allowed.

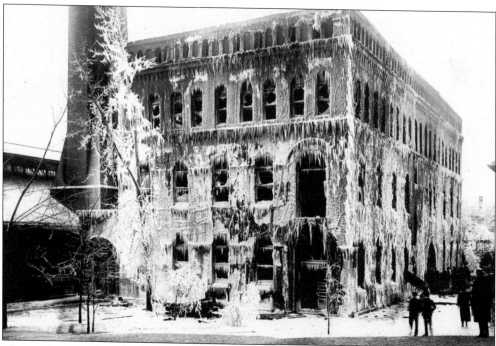

The unfamiliar building behind Houston Hall in the previous photograph is the Engineering Laboratory. It was joined to the university's power plant, allowing mechanical engineering students to work directly with the machinery providing Penn's heat and electricity. This photograph shows the laboratory after it was destroyed by a fire in February 1906, leaving the university temporarily without power. The engineering departments immediately moved into the nearly completed Towne School.

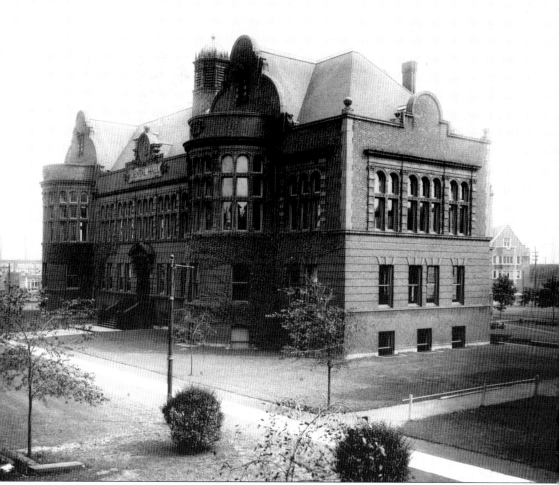

Dental Hall, the new home of Penn's School of Dental Medicine, opened in 1896. The dental clinic occupied the entire second floor. Beginning in 1915, this versatile building next housed the School of Fine Arts, and the clinic became a studio for architecture students. When that school moved to a new building, the Department of Geology moved in and named the building Hayden Hall after Ferdinand Hayden, 19th-century professor of mineralogy and geology at Penn. Today, Hayden Hall is part of the School of Engineering and Applied Science. Behind Dental Hall and visible to its right is Weightman Hall, Penn's gymnasium, which was finished in 1904, two years before this photograph was taken. To the right of Weightman Hall appears an early version of Franklin Field. It had a capacity of 20,000 and was completed in 1905.

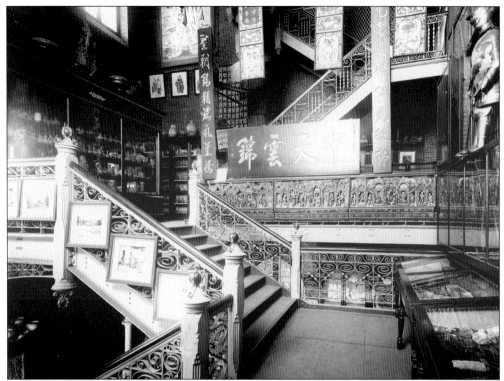

Until the first stage of the University Museum was completed in 1899 (as the Free Museum of Science and Art), its collections were kept at the University Library. Many items were brought back from archaeological expeditions, whereas others came to the university as gifts. The collections quickly outgrew the space available at the library, as this 1898 photograph of museum exhibits suggests.

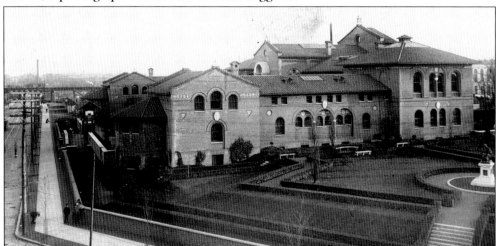

This 1910 photograph shows the first stage of the University Museum. The rotunda, a prominent feature of the museum complex today, was not completed until 1915. The statue in the lower right corner is of William Pepper, who actively supported the museum during his tenure as provost and later served as president of its board of managers. The statue is now located behind College Hall, facing Houston Hall.

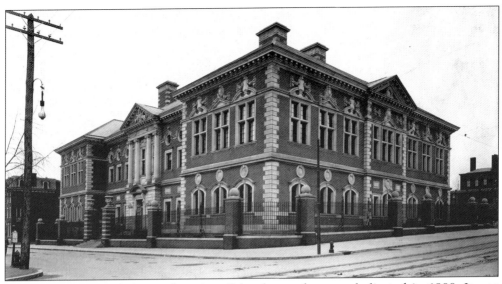

The first building of the modern Law School complex was dedicated in 1900. It was Penn's first building north of Walnut Street. The Law School moved from central Philadelphia to occupy it. At the new building's dedication ceremonies, Provost Charles C. Harrison said, "The mother has had an adult child in separate and distant lodgings. Hereafter and henceforth, we are all to be together."

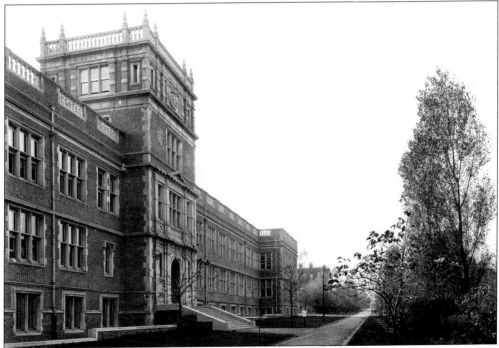

In 1904, the laboratories of pathology, physiology, and pharmacology were completed on Hamilton Walk, a section of Pine Street given to Penn by the city. The walk was named after James Hamilton, a former president of the board of trustees. When most medical classes moved to the new laboratory building, shown here in 1904, the Wharton School took over the old Medical Hall, renaming it Logan Hall.

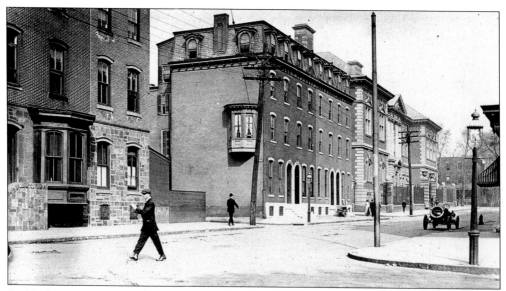

In 1913, Penn made 12 rooms available for female graduate students of the School of Arts and Sciences in four houses south of the Law School on 34th Street. A dining hall and common rooms were open to all Penn women. Penn named this early dormitory Sergeant Hall after Hannah Sergeant, the wife of John Ewing, Penn's second provost. The houses are marked by their arched doorways in this 1912 photograph.

Penn purchased an apartment building on the northeast corner of 34th and Chestnut Streets in 1924 to be a new women's dormitory. The name Sergeant Hall was transferred to the new building. The dormitory, shown here in the late 1940s, had rooms for about 150 women and also housed the women's dining hall. It remained a women's dormitory through the spring of 1971 and was demolished in 1975.

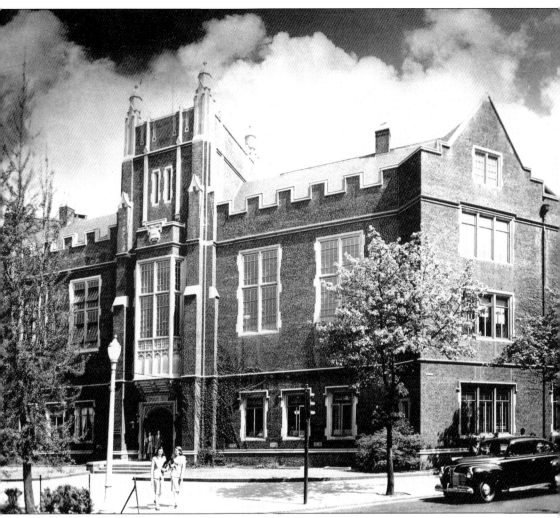

In 1889, Joseph M. Bennett gave two properties at 34th and Walnut Streets to the university for the purpose of establishing a women's college. In 1925, Bennett Hall, shown here in 1947, was opened as the new home of the School of Education, whose student body was more than 80 percent women. In 1933, it became home to the newly created College of Liberal Arts for Women. A column in the October 1, 1925, issue of the women's newspaper the *Bennett News* stated, "To those who have been here for a year or more Bennett Hall means far more than a new place. Primarily this handsome building gives the School of Education a real home. No longer does it live like an overgrown child in the already crowded College Hall. There is now a place where we really belong."

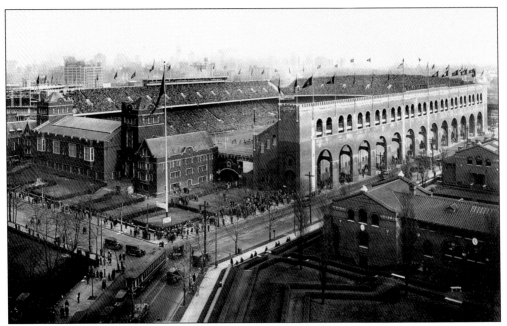

In 1895, Franklin Field was dedicated as a track with a grandstand on one side; in 1905, the first horseshoe-shaped stadium was completed; and in 1922, the first story of the modern Franklin Field was opened, with the second added in 1925. This photograph shows the Penn-Cornell game of November 25, 1926.

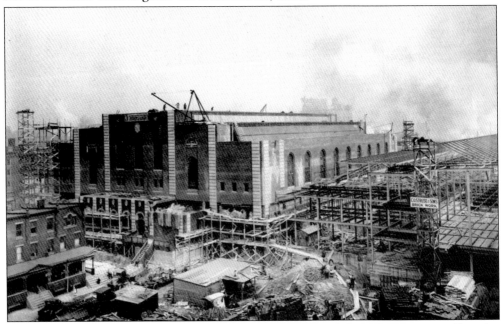

When this photograph was taken in 1926, construction of the Palestra was well under way, with construction of Hutchinson Gymnasium, on its right, at an earlier stage. The Palestra was dedicated on January 1, 1927, and 10,000 spectators watched Penn beat Yale 26-15 in the first basketball game held there. Tennis courts rather than row houses now occupy the space in front of the Palestra.

The William B. Irvine Auditorium, named for a former city treasurer whose bequest funded the building, was completed at 34th and Spruce Streets in 1928. This corner was formerly the site of the university's Engineering Laboratory and power plant. The first events to take place in the auditorium were the baccalaureate ceremony and Class Day in June 1928. The following summer saw the installation of a huge pipe organ that was originally constructed for Philadelphia's Sesquicentennial Exhibition in 1926. It was called the Curtis Organ because Trustee Cyrus H. K. Curtis had purchased it for the university. The need for acoustical adjustments delayed the first organ performance (and the formal dedication of the building) until May 9, 1929. This photograph was taken *c.* 1929.

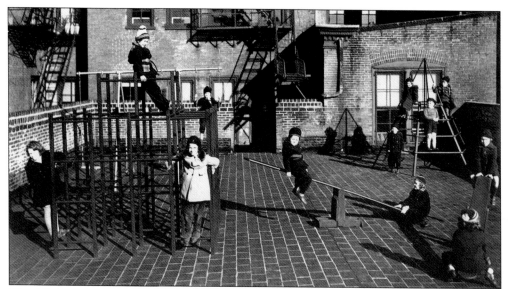

The Illman-Carter School was an independent school for teachers that included a children's school so that teachers in training could observe classes. The school moved from central Philadelphia to 40th and Pine Streets in 1921. It developed a relationship with Penn's School of Education and, in 1936, merged with Penn. This photograph of the rooftop playground was taken a few years before the children's school closed in 1959.

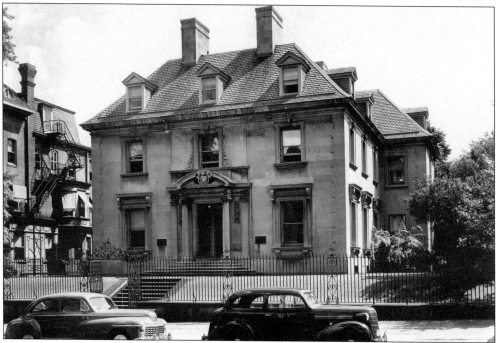

Eisenlohr Hall was built in 1911 and was bequeathed to the university by Josephine Eisenlohr in 1939. It has been the home of the university president since 1981, when Sheldon Hackney moved in. This photograph was taken in the 1940s, when Eisenlohr Hall housed the School of Education. The School of Education continued to use the building into the 1960s.

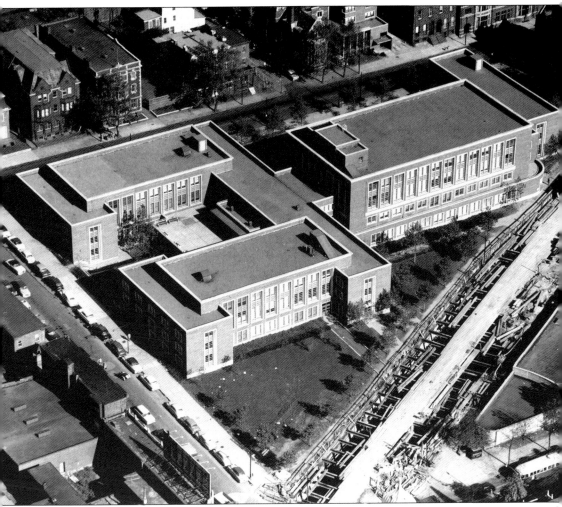

The current location of Steinberg-Dietrich Hall was marked on university maps in 1903 as the site for a new Wharton School building, but it was nearly 50 years before Dietrich Hall was built. When Logan Hall, Wharton's previous home, suffered a serious fire in 1919, reconstruction took priority over new construction. The groundbreaking finally took place in 1950, and the new building was dedicated in October 1952. This photograph, taken from an airplane in 1954 by Julian Wasser, then a senior at the College and photography editor of the *Daily Pennsylvanian,* shows the new building and the major construction project that was an early part of the creation of Penn's pedestrian campus. The city was extending the subway from 36th Street to 40th Street, which would allow the trolley routes to be removed from Woodland Avenue.

On January 11, 1958, Founder's Day celebrations featured the official closing of Woodland Avenue from 34th to 37th Street. Woodland Avenue passes between the crowd members, with their backs to Logan Hall, and Pres. Gaylord Harnwell at the podium; behind him is the intersection of Locust and 36th Streets, both of which were still open to traffic.

Less than one month later, on February 5, 1958, Penn celebrated the demolition of two buildings on the northeast corner of 34th and Walnut Streets. The clearing of the area bounded by 34th, Walnut, 32nd, and Chestnut Streets had begun. On the right is the Woodland Avenue façade of the Zeta Psi fraternity, which still stands at the corner of 34th and Walnut Streets.

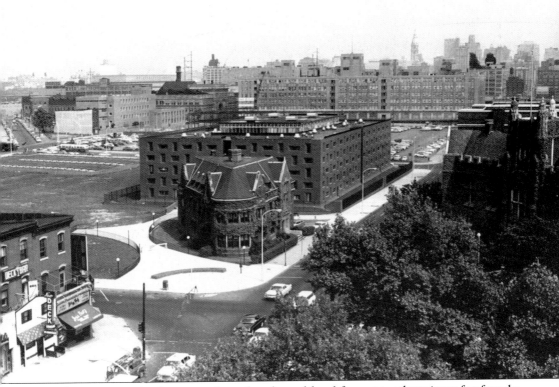

In April 1959, Penn broke ground on the cleared land for a new dormitory for female students. The dormitory included many spaces named in honor of Penn alumnae and famous women of Philadelphia. Women moved into their new rooms in November 1960. The new residence hall was formally dedicated as part of Founder's Day festivities on January 14, 1961. This photograph was taken in the summer of 1961 from the roof of the Van Pelt Library, which was under construction. It shows the Zeta Psi fraternity in front of Hill House. Woodland Avenue has been removed between 33rd and 34th Streets but still passes through the campus of Drexel University in the upper left corner of the photograph. In the lower left corner, the New Deck Tavern, which has since moved around the block to Sansom Street, faces Walnut Street.

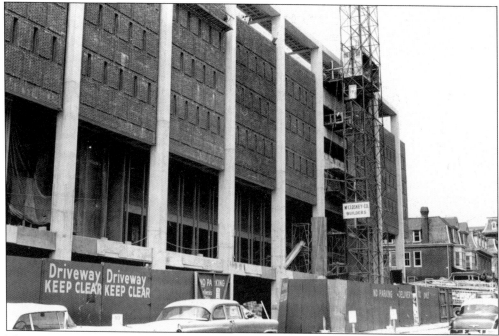

The construction of the Charles Patterson Van Pelt Library, shown here in 1961, was another big change for Walnut Street. When the University Library moved into its own building in 1891, the collection consisted of 55,000 volumes; the total was nearly one million for the move in March 1962. The Dietrich Graduate Library replaced the houses to the right of Van Pelt on Walnut a few years later.

The Annenberg School for Communications, founded in 1959, is the youngest of Penn's 12 schools. The first courses offered in the fall of 1959 included Mass Communication in the Growth of America and Research and the Mass Media. The school's new building opened in the fall of 1962. In this *c.* 1970 photograph, the Annenberg Center for the Performing Arts is under construction next-door.

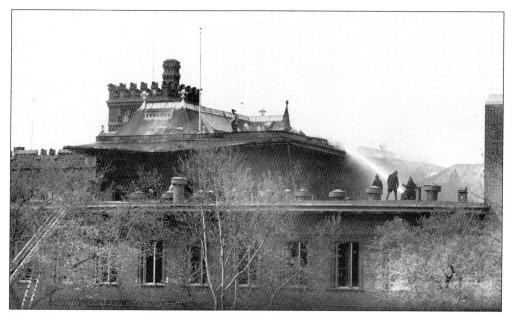

The John Harrison Laboratory of Chemistry was built at the corner of 34th and Spruce Streets in 1894. It was seriously damaged by a four-alarm fire on Easter Sunday, April 21, 1957, as approximately 2,000 spectators watched. The estimated damage was $100,000 to the building and $100,000 in lost equipment. The brick building to the right is the 1940 Cret Chemistry Building, which was not damaged in the fire.

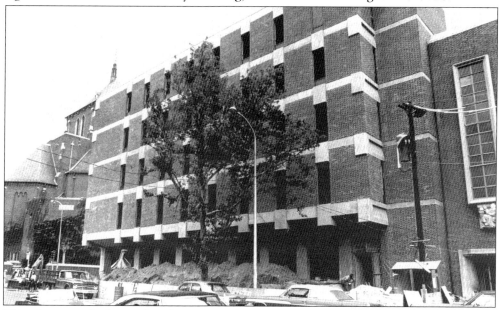

This photograph shows the Chemistry Laboratories under construction in 1972 at 34th and Spruce Streets. The Cret Chemistry Building, now the oldest part of the chemistry complex, is to their right. It is the only campus building designed by architect and faculty member Paul Cret. "Old Harrison" was demolished in 1970, and the 1973 Chemistry Laboratories, housing labs, a lecture hall, offices, and the chemistry library, were dedicated in March 1974.

The expansion of the pedestrian campus westward continued as Locust Street became Locust Walk. The block between 36th and 37th Streets was ceremonially closed on Alumni Day, May 18, 1963. In 1971, a bridge was constructed over 38th Street to extend Locust Walk to the Superblock dormitories that had been built in 1969 and 1970. This photograph was taken in 1973.

With the construction of the high-rise Harrison, Harnwell, and Hamilton College Houses, Penn expanded upward. The dormitories in the Superblock bounded by 38th, Walnut, 40th, and Spruce Streets were built to house more than 3,000 students. This 1971 photograph spans the history of residential housing at Penn, capturing both the high-rises and, to their left, the four turrets of Memorial Tower, completed in 1900.

Two

Lessons and Books

Academic Pursuits

*As to their Studies, it would be well if they could be taught every
Thing that is useful and every Thing that is ornamental:
But Art is long, and their Time is short. It is therefore propos'd that
they learn those Things that are likely to be most useful and most ornamental.*

—Benjamin Franklin, 1749

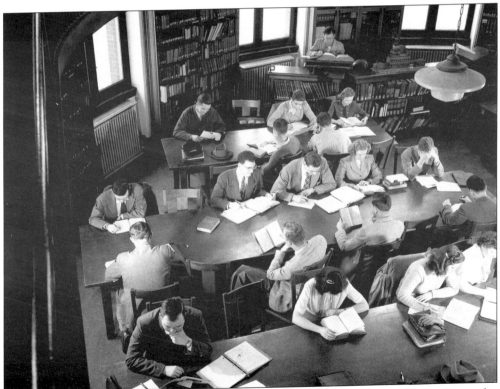

The reading room of the University Library appears here in the late 1940s. Since the university's founding, the education that it has provided has changed in almost every way imaginable, including what subjects have been taught, how they have been taught, and to whom they have been taught.

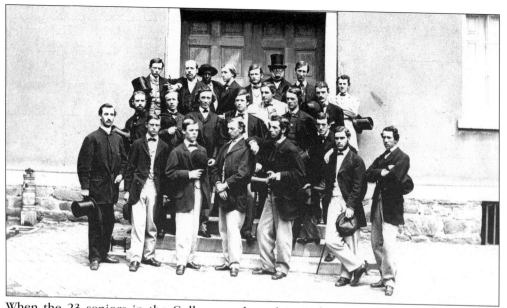

When the 23 seniors in the College graduated in 1865, Penn was still at its second campus. Except for one student each from New Jersey and North Carolina, all were from eastern Pennsylvania. The men in hats in the back row are janitor's assistant Albert Monroe "Pomp" Wilson (left), who worked at Penn until his death in 1904, and janitor Frederick Dick (right).

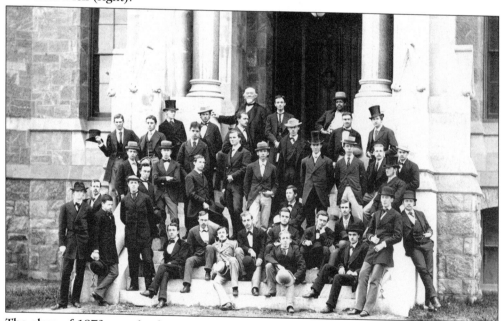

The class of 1873 was the first graduating class on the West Philadelphia campus. The students of the College were still predominantly local. College Hall contained all the classrooms, laboratories, and offices of the College, as well as the chapel and library. In addition to required courses in philosophy and physics, seniors had a choice between further studies in classical or modern languages and between advanced mathematics or English literature.

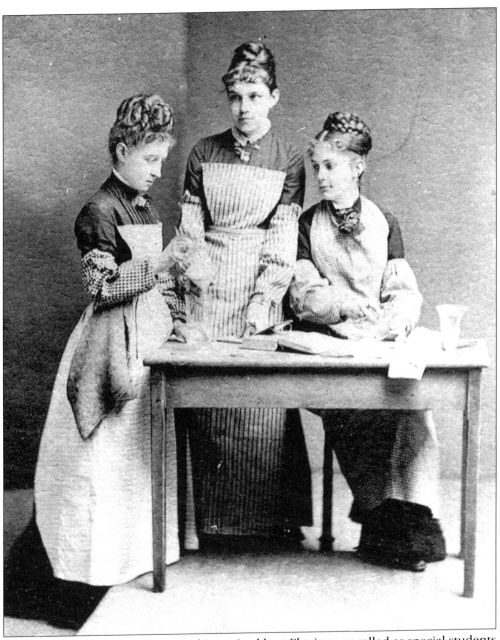

In 1876, Gertrude Klein Peirce and Anna Lockhart Flanigen enrolled as special students to study chemistry. They were the first women to be admitted to collegiate courses customarily leading to a university degree. As special students, however, Peirce and Flanigen were not eligible for a degree but instead received certificates of proficiency. This photograph from the 1878–1879 school year shows, from left to right, Peirce, Flanigen, and Mary Thorn Lewis, the third woman to enroll when she started at Penn in the fall of 1878. Gertrude Peirce later commented, "We never said a word to any of the boys working side by side with us. . . . You see, it was outrageous enough in the first place that we should be allowed to attend a man's class. But to talk to any of the students—well, that wouldn't have done at all."

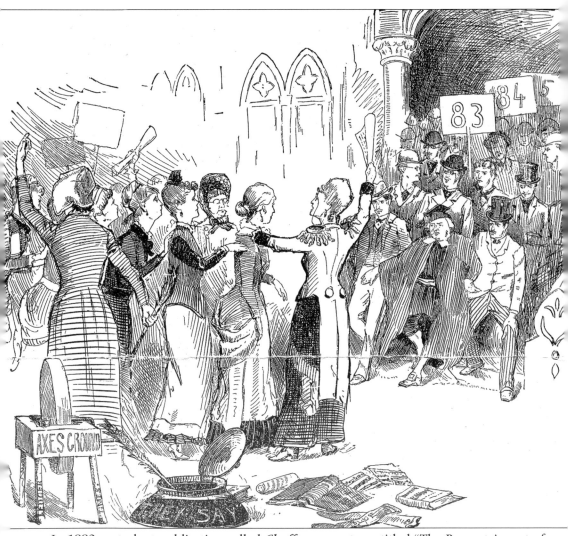

In 1882, a student publication called *Chaff* ran a cartoon titled "The Present Aspect of Co-Education" concerning the question of admitting female students. It shows an army of women besieging College Hall. The women have thrown to the ground books titled *How to Bake Bread* and *Domestic Economy,* and in front of them lie a pair of stockings labeled "BLUE." The cartoon reappeared in an issue of *The Red and Blue,* another student publication, in the early 1920s, when the question was still very much under discussion. In 1918, George F. Snyder, an alumnus who had started at the Wharton School and graduated with a law degree, wrote, "I don't know a thing about the merits of the question; but I do know that I should not have gone to Penn if the Wharton School had been coed."

Nathan Francis Mossell, who received the degree of doctor of medicine in 1882, was the second African American student to graduate from Penn (the first was James Brister, who had received a doctor of dental surgery degree in 1881). Mossell had earned his bachelor of arts degree from Lincoln University in 1879. In 1888, his younger brother Aaron became the first African American student to graduate from the Law School. Trained after graduation by Prof. D. Hayes Agnew in the University Hospital, Nathan Mossell pursued additional post-graduate studies in hospitals in London. In 1888, he was the first African American physician to be elected to membership in the Philadelphia County Medical Society. In August 1895, he was the leading figure in the founding of the Frederick Douglass Memorial Hospital and Training School. He served as chief of staff and medical director there until his retirement in 1933.

This photograph of a civil engineering drawing room in College Hall was taken *c.* 1885, when the Towne Scientific School was still part of the College. According to the 1884–1885 *Catalogue,* "Students . . . are instructed by recitations, lectures, and practical work. . . . Afternoons and Saturdays are devoted to drawing and practical work in the shop, or to surveying or visiting public or private works, manufactories, etc."

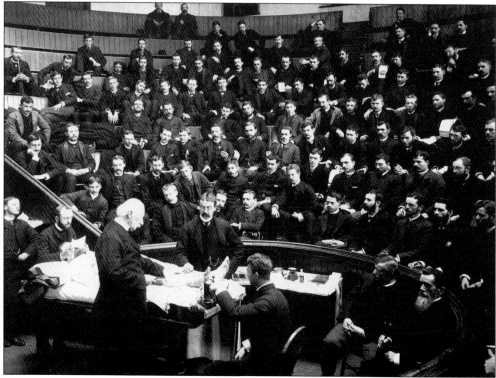

D. Hayes Agnew, standing in front of the patient in the operating theater, was a professor of surgery at Penn from 1870 to 1889. A student took this photograph in 1886. Prof. J. William White, standing at the patient's foot, later noted, "The period was that during which we employed the carbolic spray [for antisepsis] for all operations, but before the use of operating gowns had come into vogue here."

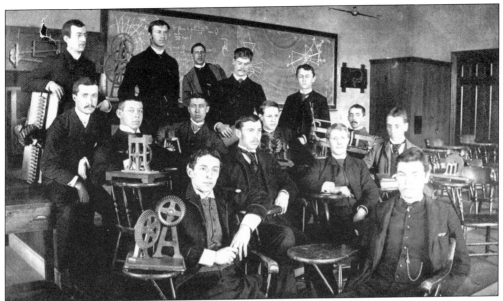

The Towne Scientific School was founded in 1875. Towne freshmen and sophomores followed the academic program of the College with two deviations: extra mathematics and no classical languages. As juniors and seniors, they focused on technical training. The men in this 1887 photograph were seniors in the Dynamical Engineering section, whose study of kinematics included "trains of gearings and forms of teeth of wheels."

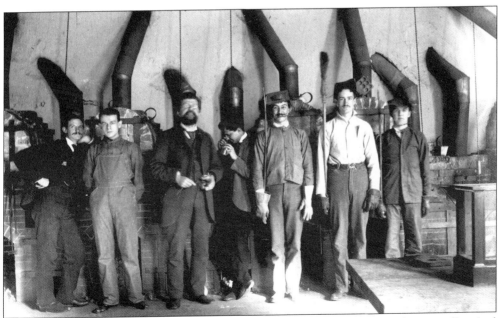

The Towne School also had a Mining and Metallurgy section. The metallurgical laboratory was in the basement of College Hall. Third from the left is George A. Koenig, professor at the Towne School from 1875 to 1892. After Koenig's death, a former student wrote, "He sometimes seemed to lack method in his instruction, but nevertheless his course left nothing to be desired."

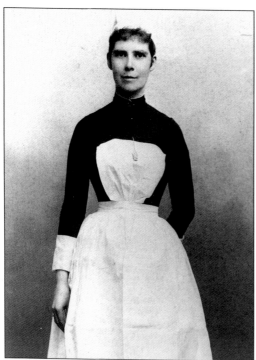

The University Hospital's Training School for Nurses was organized in 1886 to provide a reliable source of well-trained nurses for employment in the hospital. In 1887, after one year of study, Mary J. Burns received the first certificate awarded by the Training School. The dark-blue dress with a pinned bib was the uniform of the student nurses; graduates had aprons with straps.

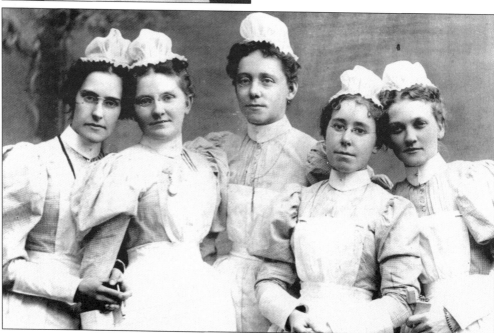

In 1893, the nursing curriculum was extended to three years. It included studies in hygiene, anatomy, physiology, medical and surgical nursing, pharmacology, toxicology, urinalysis, splints, bandaging, gynecology, obstetrics, children's diseases, the rest cure, electro-therapeutics, massage, "care of the insane," and nutrition. This is an 1898 photograph of first-year student nurses on night duty (9 p.m. to 7 a.m). They graduated two years later in a class of 31 women.

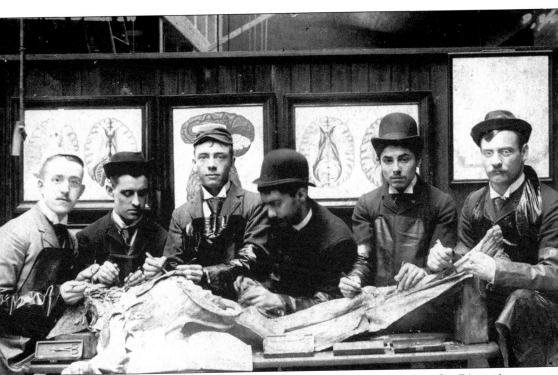

This 1890 photograph shows a group of first-year medical students in the Dissecting Room. The room occupied the entire top floor of the Laboratory Building at 36th and Spruce Streets, where Williams Hall now stands. The 1889–1890 *Catalogue* explained that the room "is lighted by windows on all sides, and by skylights. The most perfect ventilation is thus secured. The tables have stone tops, which cannot absorb moisture and can be kept perfectly clean. There are numerous washstands and private closets for the use of each student. Cleanliness is rigidly enforced. The preservation of the cadaver has been so successfully accomplished as almost to do away with the dangers of dissecting wounds. Dissection is legalized in Pennsylvania."

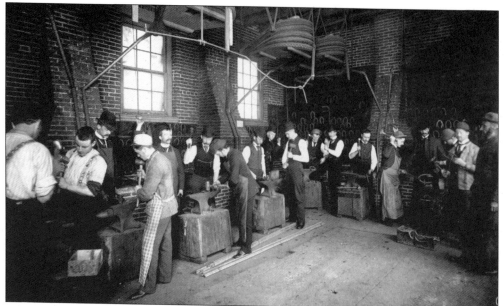

For the first 25 years of the Department of Veterinary Medicine, horseshoeing was a required course for first-year students. This *c.* 1900 photograph shows a class at the Veterinary Hospital's blacksmith shop. The *Catalogue* described the course as "about twenty lectures illustrated by charts, prepared hoofs and shoes, frequent visits to the shoeing forge, and practical demonstrations upon the living horse at rest and in motion."

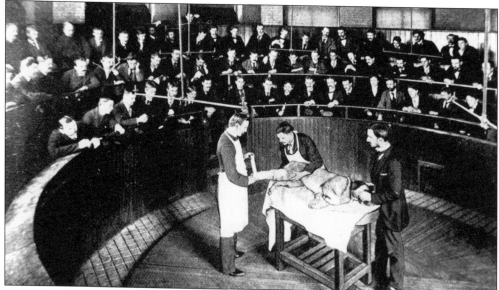

In this *c.* 1897 photograph, veterinary students observe a surgical demonstration. At that time, dogs and other small animals were treated at Penn's Hospital for Small Animals. A graduate of the veterinary school wrote, in regard to the development of canine practice, "Gradually, veterinarians who were lovers of dogs began to minister to [them] and by their example compelled the profession to recognize this hitherto despised animal."

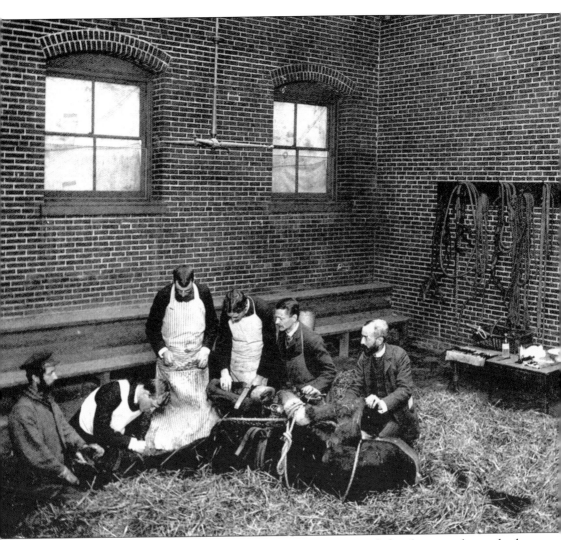

Third-year veterinary students, under the supervision of faculty members, had responsibility for cases at the Veterinary Hospital. Their duties included keeping records, administering medicines, changing dressings, and performing operations. This 1900 photograph shows students in one of the operating rooms of the hospital. In 1900, the Department of Veterinary Medicine was still less than 25 years old. There were 46 veterinary students that year, and 11 men received the degree of doctor of veterinary medicine. In his report to the provost for 1899–1900, Leonard Pearson, dean of the department, stated, "The conditions and character of veterinary work have changed materially during the past few years; and it is important that the training of students who wish to become veterinarians shall be such that they will be prepared as well as possible to meet the demands upon them in practical life."

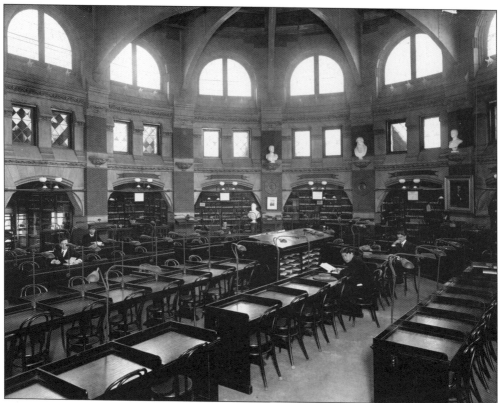

This photograph was taken in 1903 in the reading room of the University Library, now the Fisher Fine Arts Library. In the early 1900s, the library was becoming more accessible to its student users. A card catalogue, arranged by author and subject, was completed in 1900. In 1903, the trustees authorized the library to change its weekday closing time from 6 p.m. to 10 p.m. during the school year.

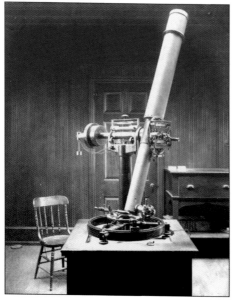

In 1895, Penn completed construction of the Flower Observatory on farmland just west of Philadelphia. In 1899, astronomy became an independent department, after more than a century of being taught in connection with either natural philosophy or mathematics. This 1904 photograph shows one of the telescopes at the observatory, where both undergraduate and graduate astronomy students worked. The observatory was also open to the public on Thursday evenings.

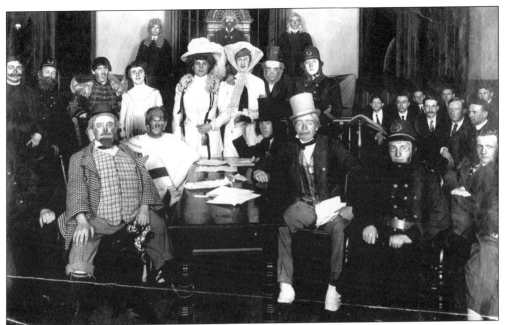

The performance in this photograph was a mock trial in the Department of Law in 1908. The department yearbook quoted the supposed opening of court: "Oh, yes; oh, yes. This is the scream court for the 23d circus of the Eastern District of the Law School. . . . All those having business, doing business or desiring to do business who now slip up to the bar can hit one another."

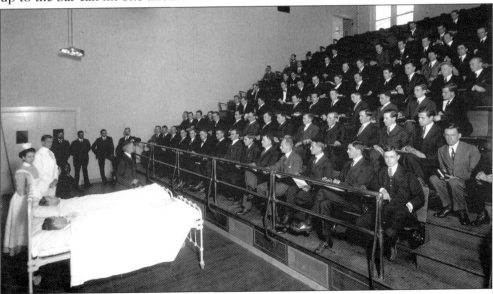

Between 1886, when Dr. Agnew presided over his clinic, and 1908, when this photograph was taken, expectations for medical students changed. By this time, the curriculum had expanded from three years to four. Pedagogically, teaching started to shift from large "didactic lectures" to an emphasis on smaller groups of students, although this photograph shows that large lectures still had a place in the medical curriculum.

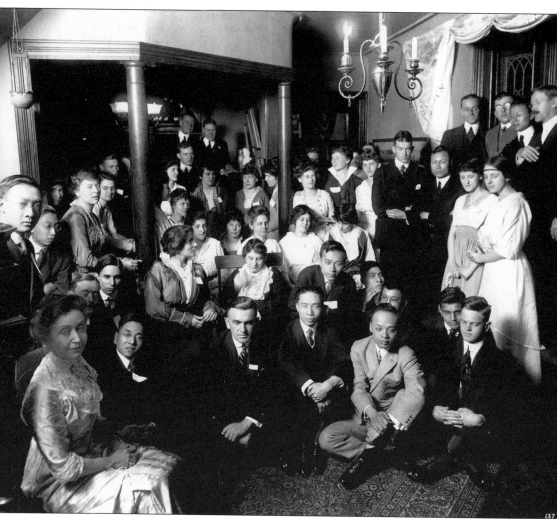

Penn started to attract international students in the late 19th century. By 1911, international students numbered approximately 200 out of 5,200. Alpheus Waldo Stevenson and his wife, Anna, opened their home on Larchwood Avenue to the international students for social gatherings on Friday evenings. Stevenson was an alumnus of the College and a Presbyterian minister, and he had worked in Cuba. When this photograph was taken in the Stevensons' home *c.* 1912, there were students at Penn from countries such as Australia, Brazil, Canada, China, Cuba, Denmark, Egypt, France, Germany, Holland, Italy, Jamaica, Japan, Mexico, New Zealand, the Philippines, Russia, South Africa, Turkey, and Venezuela. Brazil had the largest number that year with 19, followed by Australia with 16. These mirror the numbers of students coming from the states of California and Georgia, respectively, in the same year.

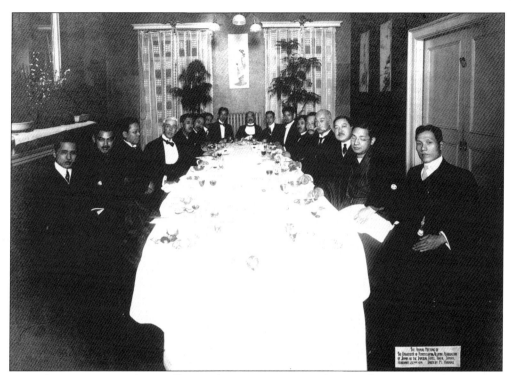

On February 22, 1914, J. William White, emeritus professor of surgery and a trustee, paused in a trip around the world to join a meeting of the University of Pennsylvania Alumni Association of Japan. Here, he sits fourth from the left. The alumni with whom he dined at the Imperial Hotel in Tokyo represented three decades of Japanese students at Penn, beginning with Penn's first Japanese graduate in 1879.

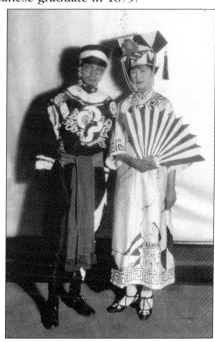

At the end of the 19th century, thousands of Chinese students began to go abroad to Europe, Japan, and the United States for scientific and technical studies. Penn had one of the largest groups of such students in America. In the 1920s, several Chinese students studied architecture at Penn. In this photograph, Shicheng Liang (left) and Phyllis Whei-yin Lin are in costume for the 1926 Architects' Ball.

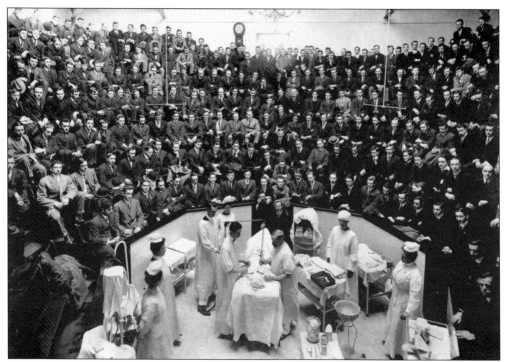

At the start of the 20th century, the Department of Dentistry added oral surgery to its curriculum as a reflection of a broadening definition of dentistry. The surgical clinics were held in the University Hospital and Philadelphia General Hospital. This photograph, likely taken very early in the 1900s, shows the oral surgery clinic at Philadelphia General Hospital, located just south of the University Hospital.

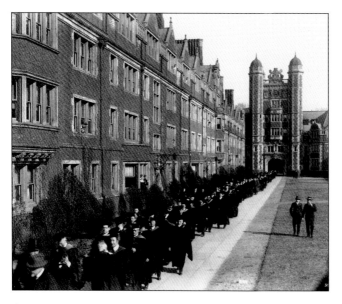

On February 22, 1915, Penn dedicated the Thomas W. Evans Museum and Dental Institute. The academic procession assembled at Houston Hall, passed through the Quad, and marched to the new building at 40th and Spruce Streets. The alumni newspaper *Old Penn* reported that "the procession was the most impressive one that has ever appeared on the campus" and that an audience of 2,000 observed the dedication ceremonies.

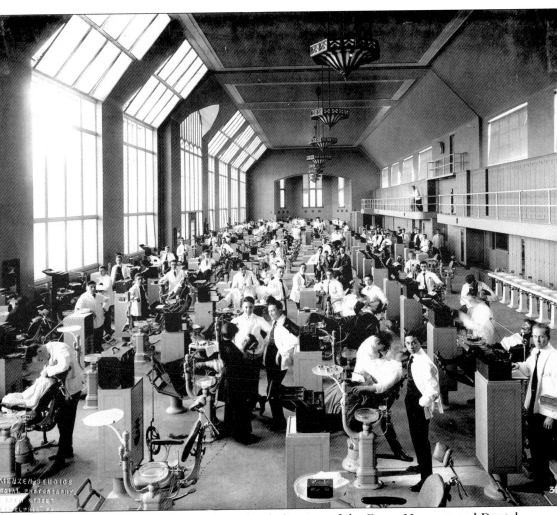

The second day of festivities marking the dedication of the Evans Museum and Dental Institute consisted of an open house and more than 60 clinics to which dentists and all alumni were invited. This photograph of the operating room was taken in the building's first year. The 1915–1916 *Catalogue* boasted, "The clinical operating room occupies one entire floor of the building . . . furnished with one hundred and thirty-four latest pattern Diamond operating chairs, each provided with a fountain cuspidor, with running water attached, and attachment for the Fisk saliva ejector, a bracket arm, and table for holding instruments, besides a separate cabinet and table for the instrument case." Students began to work in the operating room in their second year and had to provide their own instruments, "except those for extracting."

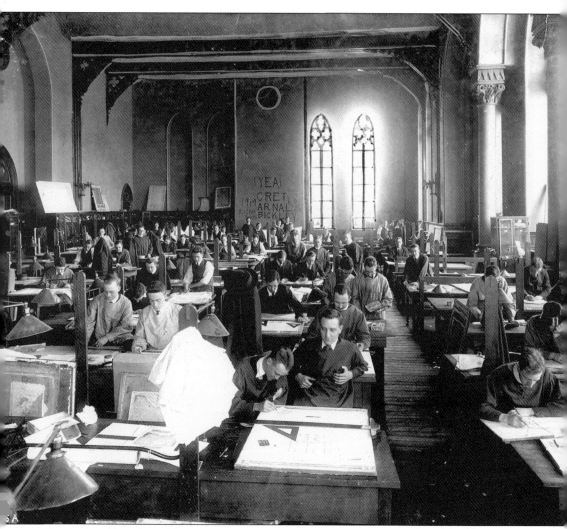

In 1915, when this photograph was taken, Penn's School of Architecture was still a division of the Towne School. This drafting room in College Hall was formerly the university's chapel. When the architecture students moved in, chapel services shifted to the auditorium of Houston Hall. According to Ann L. Strong and George E. Thomas in *The Book of the School: 100 Years,* underclassmen worked as assistants to upperclassmen in the studio, and upperclassmen also assisted faculty in criticism of student work. On the back wall, names of members of the architecture faculty are painted. The most famous is that of Paul Philippe Cret, French architect of the Beaux-Arts school who taught at Penn from 1903 to 1929. As professor of design, he oversaw the studio, or *atelier*. Later in 1915, the architecture program moved to the former Dental Hall.

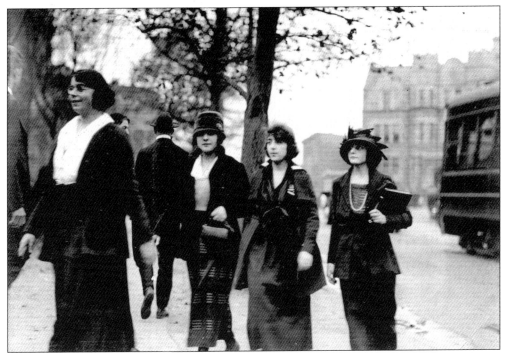

More than 320 women were Penn undergraduates during the 1918–1919 academic year. The president of the Women's Undergraduate Association reflected in the 1919 women's yearbook, "Peace meant varied things to the men at the University, but to the women it was freedom once more to be truly, not feignedly, happy; to drop back into the pleasant combination of work and play which had made life at Penn so attractive before the war."

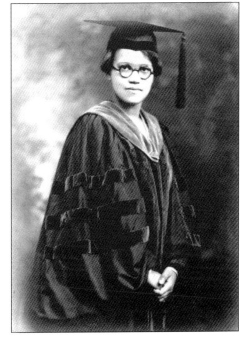

Sadie Tanner Mossell, niece and daughter of Penn's first African American graduates in medicine and law, became the first African American woman to earn a Ph.D. in economics in 1921 (the occasion of this photograph). Following her marriage to Raymond Pace Alexander, a graduate of the Wharton School and Harvard Law School, she became the first African American woman to earn Penn's law degree in 1927.

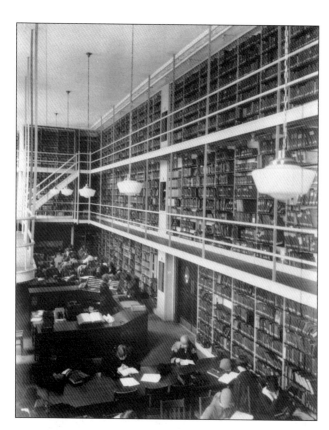

The Penniman Library of Education in Bennett Hall appears here *c.* 1930. At the founding of the School of Education in 1914, James Hosmer Penniman, brother and housemate of Vice Provost Josiah Harmar Penniman, made a gift to Penn of 25,000 volumes on education. The namesake of the library was in fact the mother of the Penniman brothers—Maria Hosmer Penniman.

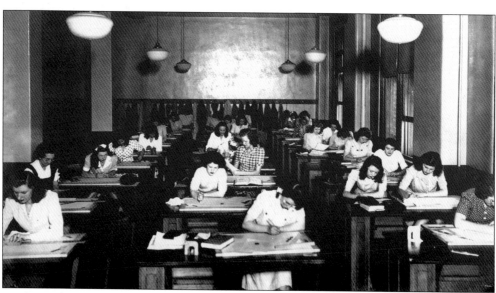

By the 1940s, when this photograph was taken, the College of Liberal Arts for Women allowed women to earn the degree of bachelor of arts under the same curriculum as the male students. The College for Women's *Announcement* noted, however, "As far as possible, separate classes and sections are provided for women students taught by members of the faculty of the College."

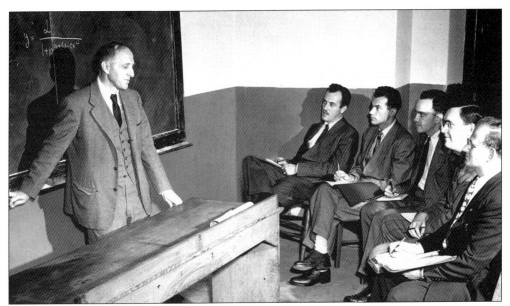

This *c.* 1946 photograph shows a Wharton graduate class led by Prof. Simon Kuznets, who won the Nobel Prize for Economics 25 years later in 1971. Edward Brink (far left) and Morris Hamburg (beside Brink), former undergraduate students at Penn, earned both an M.A. and a Ph.D. in economics and ultimately joined the Wharton faculty.

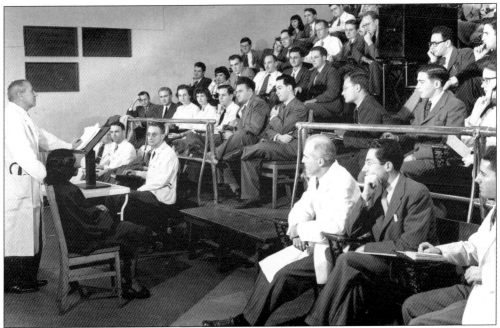

A lecture occurs at the School of Medicine *c.* 1947, as the curriculum returns to normality following World War II. During the war, the medical school adopted an accelerated schedule that made it possible for students to complete the four-year program in three calendar years. The students in this photograph are members of the last accelerated class, which graduated in March 1948.

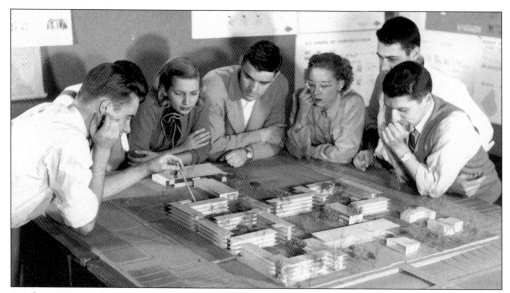

In this 1950s photograph, a group of architecture students discusses a model. The 1950s was a decade of change for the School of Fine Arts. When G. Holmes Perkins became dean of the school in 1951, he established the Departments of City Planning and Landscape Architecture. These departments, along with the Department of Architecture, eventually offered only graduate programs. The school was renamed the Graduate School of Fine Arts in 1958.

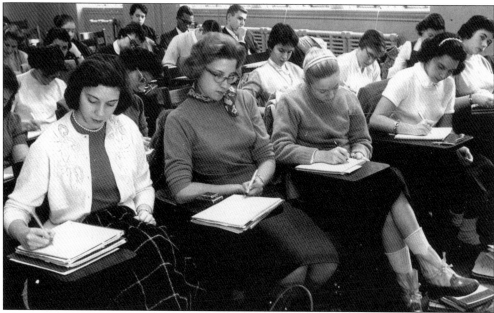

This photograph of students in the School of Education appeared on the cover of the *Pennsylvania Gazette* in 1957. The caption noted the presence of just three men in the class of freshmen and sophomores. Like the School of Fine Arts, the School of Education was increasingly emphasizing graduate studies. In 1961, it was renamed the Graduate School of Education, and undergraduate education courses moved to the College and the College for Women.

This photograph was taken in 1962 shortly before the University Library collections moved to the new Van Pelt Library. The new student handbook for 1961–1962 advised, "Books are kept in the 'stacks' . . . with numbers according to the Dewey Decimal system. It is an *unusual privilege* for University undergraduates to be admitted to the book stacks, and it is their responsibility to use the privilege wisely and carefully."

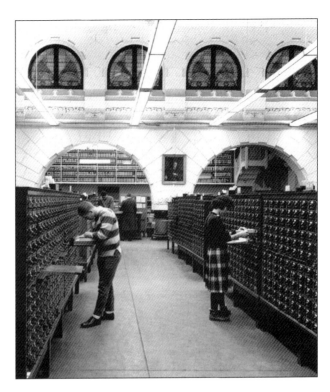

The 350-foot move from the old University Library, on the right, to the new Van Pelt Library, on the left, began in March 1962. A memo to the press from the University News Bureau promised, "Photo possibilities are excellent. Boxes of books are being packed constantly and loaded into the commercial moving vans. Meanwhile, the ebb and flow of life on campus is continuing as the movers work."

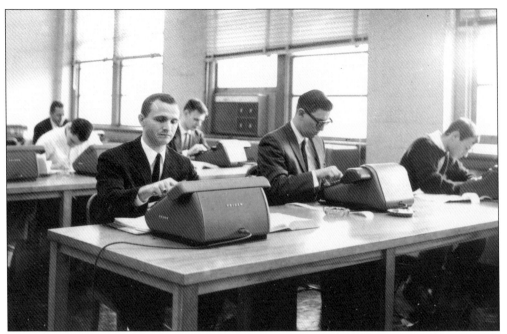

Pictured here is a Wharton class in Dietrich Hall in the 1950s. Undergraduate women were not admitted to Wharton until the fall of 1954, and over the course of 50 years they have slowly come to represent almost 40 percent of undergraduates. These students work at electric desktop calculators, which were advanced technology at the time. The ashtrays on the tables are another sign of a different era.

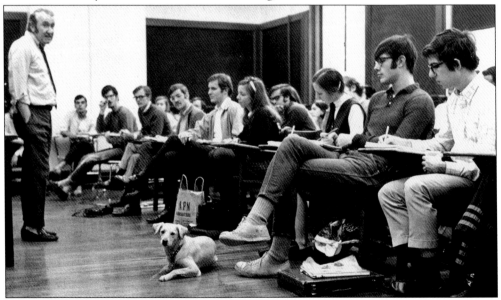

By the late 1960s, classrooms at Penn were becoming considerably more informal, as in this English class led by Prof. Robert Lucid. The 1970 yearbook staff wrote, "If education is to become an active process for all those involved, . . . if it is to transcend the artificial boundary between academics and life, then nothing less than a complete transformation of the traditional student-faculty relationship will be necessary."

Three

FUN AND GAMES

STUDENT LIFE AND ACTIVITIES

It is propos'd . . . That to keep them in Health, and to render active their Bodies, they be frequently exercis'd in Running, Leaping, Wrestling, and Swimming, etc.

—Benjamin Franklin, 1749

Here, students arrive in the Quad in the fall of 1940. Over time, life at Penn came to encompass much in addition to academics. Students also enjoyed themselves and gained experience through dormitory life, fraternities and sororities, athletic teams, performances, and other extracurricular activities.

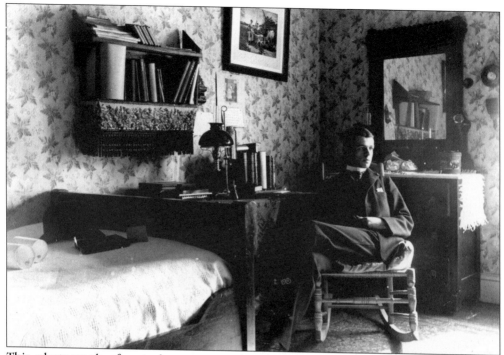

This photograph of a student room at Penn was taken in the late 1890s. The first dormitories Penn built in West Philadelphia were the houses of the Triangle, or Upper Quad. The 1896–1897 *Catalogue* explained, "The University supplies for each student the following furniture: bedstead, mattress, bureau, washstand, table, bookcase, chairs and toilet china."

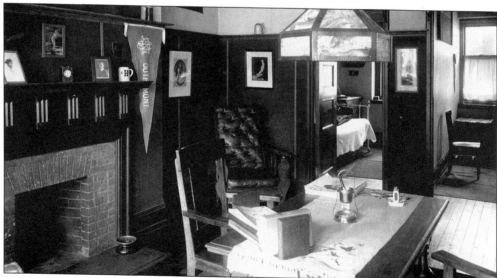

By 1917, when this photograph was taken, the Quad dormitories had rooms for approximately 1,000 students, about one-seventh of the undergraduate student body. Many of the rooms were configured *en suite,* like the one in this image, with two bedrooms and a common study. A 1915 brochure on the dormitories praised the use of burlap and plate rails on the walls as features contributing to comfort and "home-iness."

The rooms of Hill House, originally known as the Women's Residence Hall, first became available in the fall of 1960. This photograph was taken in January 1961, at the time of the building's dedication. George E. Thomas and David B. Brownlee explain in *Building America's First University* that the rooms were originally designed as singles but during the design process they were converted to doubles for economic reasons.

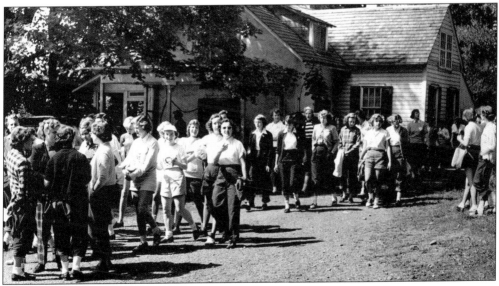

The 1924 women's yearbook describes Freshman Camp, a two-night stay at a summer camp in Green Lane, Montgomery County, with the conclusion, "That night, we came home . . . ready to be true Pennsylvanians." The camp was an optional pre-orientation activity organized by upperclassmen in the Women's Student Government Association. New students participated in campfires, singing, skits, and discussions with university administrators. This photograph appeared in a 1951 brochure for women at Penn.

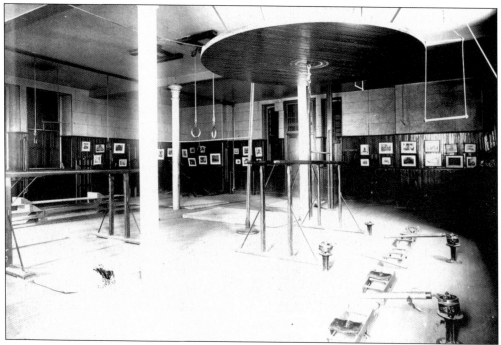

This photograph from the late 1880s shows the university gymnasium in the basement of College Hall. J. William White, the first director of physical education, stated in the *Catalogue,* "The University has fitted up a gymnasium, wherein are to be found all the latest appliances for the proper, systematic and symmetrical development of the body." The appliances in the lower right corner are 19th-century rowing machines.

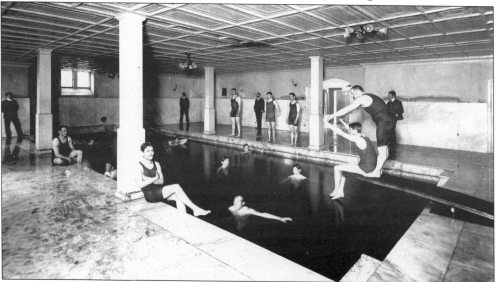

The basement of Houston Hall originally held a marble swimming pool, shown here in this *c.* 1900 photograph. The man standing on the diving board is George Kistler, "the tank tutor," who taught swimming at Penn from 1897 until 1934. In the early 1900s, Penn's Athletic Association claimed that, thanks to Kistler, Penn organized the first collegiate swimming and water-polo teams.

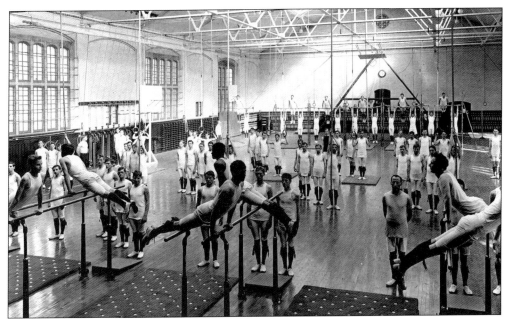

Weightman Hall, with its new, sunlit gymnasium, was dedicated in December 1904. At the dedication ceremonies, Dr. J. William White, professor of surgery and enthusiastic supporter of Penn football, recalled that when he was appointed the first chair of the Department of Physical Education at Penn in 1885, "My inaugural address was given in the chapel. There was nowhere else to give it." This photograph was taken in 1905.

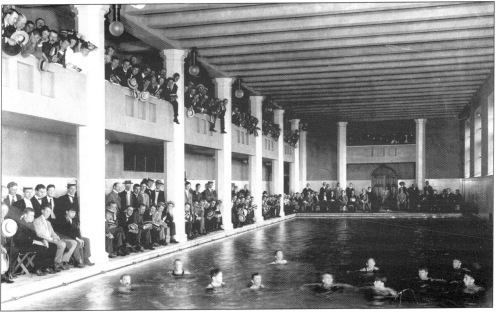

Below the gymnasium in Weightman Hall was a new swimming pool, approximately three times the size of the Houston Hall pool. In this 1905 photograph, George Kistler is the first swimmer on the left. In 1904, director of physical education R. Tait McKenzie made proficiency in swimming a requirement for all male students under the age of 21. Weightman Hall was initially not open to women.

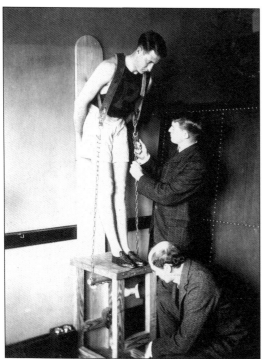

After the establishment of the Department of Physical Education in 1885, every student entering the College underwent a physical examination. As Dr. White explained, "Some men, naturally athletic and fond of exercise, need to be guided and directed. . . . Others, of sluggish temperament or of too studious habits, must be stimulated." Here, R. Tait McKenzie kneels to make an adjustment to the apparatus for testing strength, *c.* 1912.

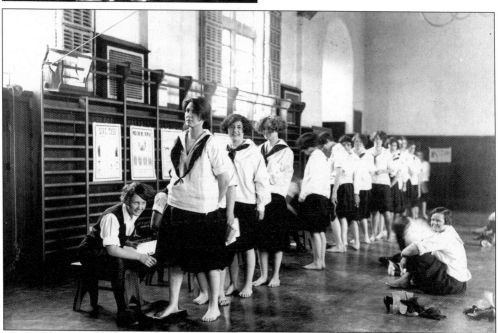

In the 1919–1920 *Catalogue,* the physical education requirement of two hours a week was extended to female undergraduates, who were almost entirely in the School of Education, and in 1921–1922, a women's medical examiner joined the staff of the Department of Physical Education to supervise the women. This 1927 photograph shows part of the female physical examination taking place in the women's gymnasium on the top floor of Bennett Hall.

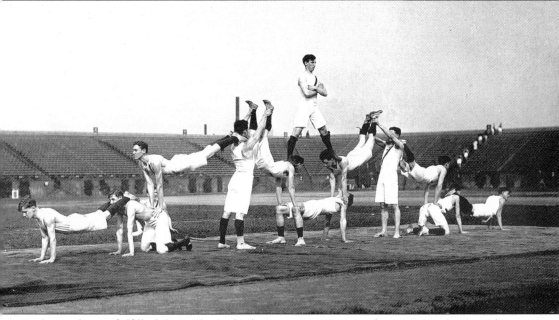

Undergraduates fulfilled their physical education requirement by participating in either team sports or gymnastic classes. In 1909, *The History of Athletics at the University of Pennsylvania* stated, "The gymnasium classes begin in November with simple marching movements and class formations followed by an examination on three pieces of apparatus. As a result of this examination the classes are divided into grades, so that as a man advances he may be promoted from grade to grade and thus have an incentive to improve himself. . . . [I]n March boxing and wrestling, gymnastic games and dancing steps are principal features. The month of April is devoted to class athletics and ends with the outdoor exhibition by the united classes about the first of May." Here, students participate in the 1913 Athletic Pageant on Franklin Field.

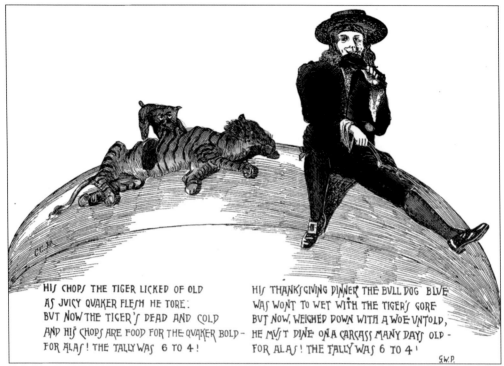

HIS CHOPS THE TIGER LICKED OF OLD
AS JUICY QUAKER FLESH HE TORE:
BUT NOW THE TIGER'S DEAD AND COLD
AND HIS CHOPS ARE FOOD FOR THE QUAKER BOLD—
FOR ALAS! THE TALLY WAS 6 TO 4!

HIS THANKSGIVING DINNER THE BULL DOG BLUE
WAS WONT TO WET WITH THE TIGER'S GORE
BUT NOW, WEIGHED DOWN WITH A WOE UNTOLD,
HE MUST DINE ON A CARCASS MANY DAYS OLD—
FOR ALAS! THE TALLY WAS 6 TO 4!

This 1892 cartoon celebrates a football victory over Princeton. Part of the accompanying verse exults, "His chops the Tiger licked of old / As juicy Quaker flesh he tore: / But now the Tiger's dead and cold / And his chops are food for the Quaker bold— / For alas! The tally was 6 to 4!" This is one of the earliest uses of a Quaker to represent a Penn sports team.

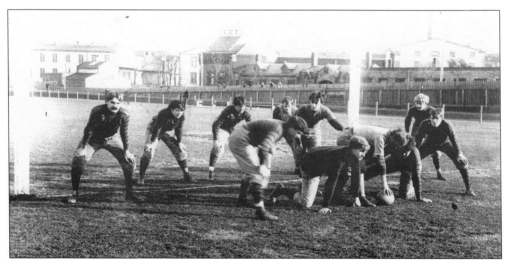

The 1892 football team appears on the field at 36th and Spruce, which was used until Franklin Field opened in 1895. George Woodruff coached the team while studying law at Penn. He went on to become attorney general of Pennsylvania and was elected posthumously to the College Football Hall of Fame. A note on the back of the photograph proudly reads, "1st Penn team to beat Princeton (6-4)."

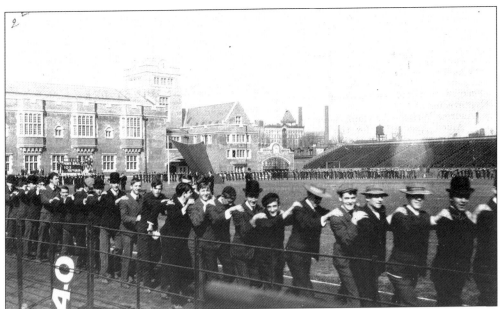

In 1904, Penn beat Harvard for the first time since 1897, and when the Penn team returned home from Cambridge, the whole school celebrated. The next day's *Pennsylvanian* reported that the students "all marched to Franklin Field, where, after performing the snake dance, the historic field flag, which has been an important emblem in many such events, was hauled down and carried to the triangle."

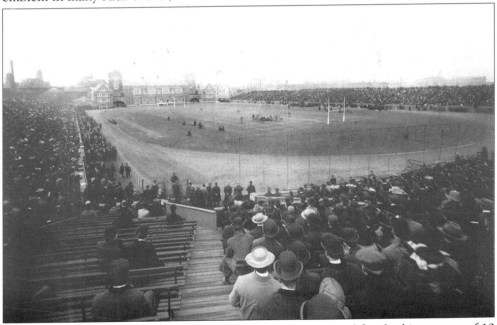

The 1904 football team continued to accumulate victories and finished its season of 12 games undefeated. One element of its success was the quarterback's hurdling of opponents, which led to a rule against this strategy. This rare informal photograph shows the crowd in the old Franklin Field at the final game of the season against Cornell. The Red and Blue won, with a final score of 34-0.

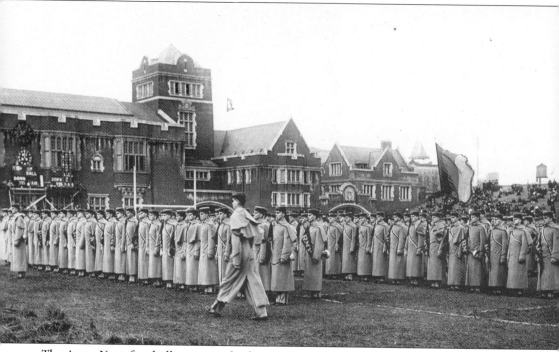

The Army-Navy football game took place on Franklin Field for the first time in 1899. In this 1910 photograph, cadets from West Point appear in formation on Franklin Field, armed with U.S. Army pennants. J. William White, who served on the U.S. Military Academy's Board of Visitors, held an organizational meeting of officers from West Point and Annapolis at his home in Rittenhouse Square. White commented to the Philadelphia press, "I think [football] should especially be played by the young men who in later life are to command our armies and our battleships. I think, too, that the cadets in both services should be given an opportunity to demonstrate that they and their friends are quite as capable of keen and manly competition in football without resulting ill feeling as are, for example, Harvard and Pennsylvania."

This 1911 photograph shows the press box at the top of the old Franklin Field's single-deck wooden stands. The two reporters closest to the camera are calling in stories or scores on old-fashioned telephones, while the man in the hat behind them is seated at a telegraph. By 1912, college football was approaching its modern format with innovations such as the forward pass and the passing touchdown.

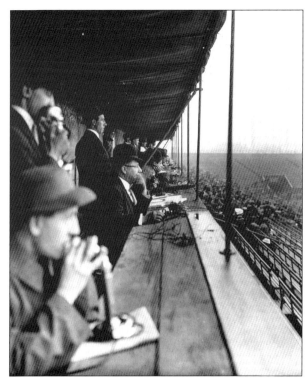

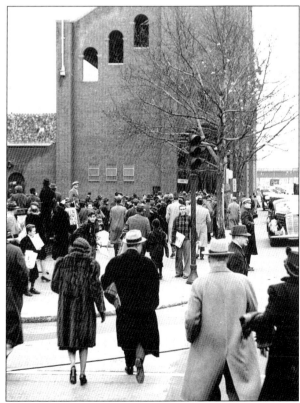

In the 1940s, under Coach George Munger, Penn football did not have a single losing season. This scene of crowds converging on Franklin Field was taken sometime during that decade, when home games often sold out. According to Dan Rottenberg's *Fight On, Pennsylvania: A Century of Red and Blue Football,* between 1938 and 1942 Penn had the highest home attendance total of any college or university in the nation.

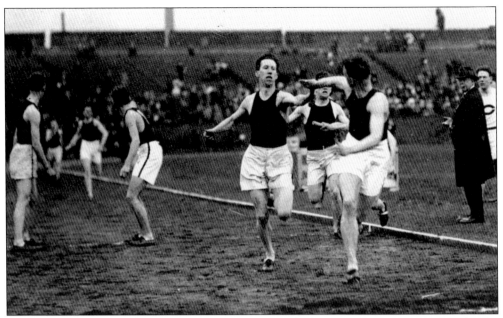

The histories of Franklin Field and the Penn Relays are inextricably intertwined. The inaugural relays of April 1895 served as the dedication for the first Franklin Field, at that time just a track with one set of bleachers along its south side. This 1917 photograph shows Frank Dorsey, captain of the track team, in the two-mile relay. Dorsey ran in the one-mile and two-mile championship relays, leading Penn to victory in both events.

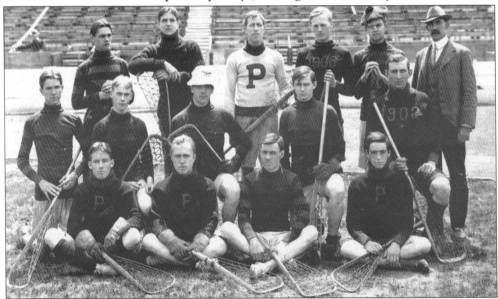

Team photographs were traditionally taken in a studio or in front of the doors of Weightman Hall, but Franklin Field is the backdrop of this unusual photograph of the 1902 lacrosse team. Lacrosse first came to Penn in 1900, and like basketball before it, support from the Penn Athletic Association lagged behind student participation. Unlike basketball, lacrosse was temporarily abandoned, ceasing after 1905 and not resuming until 1913.

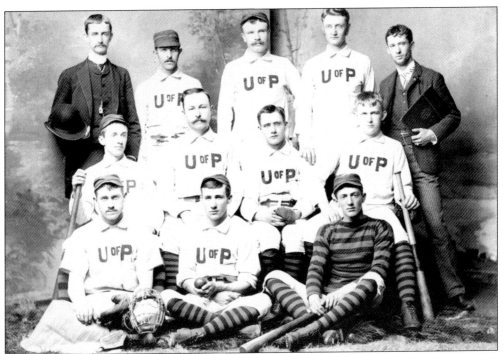

Baseball at Penn had a somewhat haphazard start. Penn first played intercollegiate games with Swarthmore College in 1875, but in some early years, no games were played. The 1886 team, shown here, was one of the first to play a scheduled season. By the end, the team managed to eke out a winning record of 11-9. They lost their unofficial games against professional teams based in Philadelphia and Baltimore.

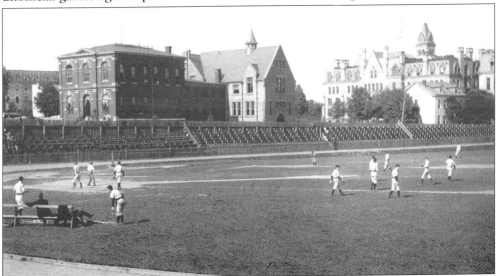

This 1891 photograph shows baseball practice on the field at 36th and Spruce Streets, with Medical Hall, now Logan Hall, in the background on the right. Penn baseball was becoming more successful; one summary of the season noted that of the team's four losses, "two defeats were caused by listless playing on Pennsylvania's part and would have been won if the team had done themselves justice."

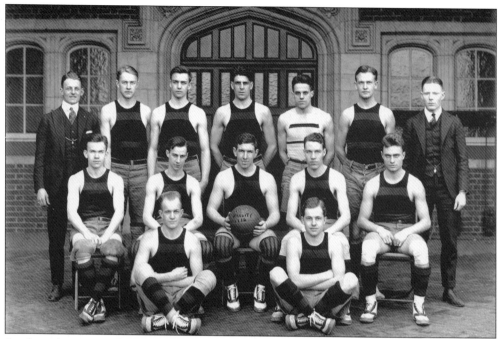

Students began to play basketball in 1896, but the Penn Athletic Association refused to recognize the sport before 1903, until which time the players covered the team's expenses. In 1908 and 1916, the basketball team won the intercollegiate championship. The 1916–1917 team, seen here, was the first to play after basketball was recognized as a major sport at Penn, joining football, baseball, track, and crew.

In 1955, Penn, LaSalle, St. Joseph's, Temple, and Villanova organized a city basketball league with all games to be played at the Palestra. The league became the Philadelphia Big 5. Penn struggled in the first years but finally achieved its first Big 5 victory, over LaSalle, in December 1957. Penn's captain that year was senior Dick Censits. He was named to the Big 5's First Team in each of the league's first three years.

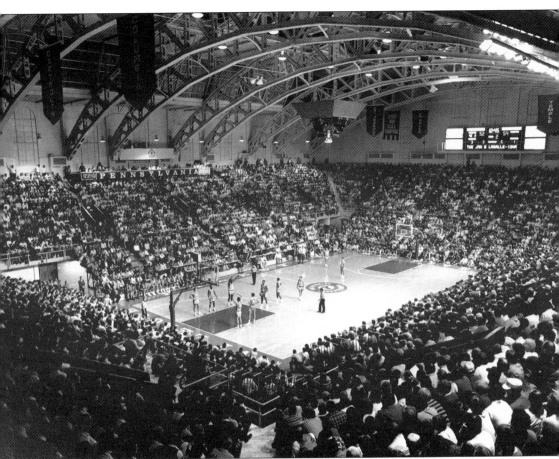

This photograph shows the Palestra in the late 1970s. In this decade, Penn won the Ivy League title eight times and the Big 5 title seven times. The Quakers capped the decade with a trip to the Final Four in 1979, beating the University of North Carolina, Syracuse, and St. John's before losing to Michigan State in the semifinals. Paul Zingg, in *Pride of the Palestra: Ninety Years of Pennsylvania Basketball,* describes the excitement and loyalty of the Palestra crowds: "Throughout the Quaker decade, Penn fans were among the most knowledgeable and clever around. They could devastate opponents' followers with their decent wit as effectively as their team took care of business on the court below. The fans and the players developed a mutual appreciation for each other and the victories they shared were a 'team' experience in more ways than one."

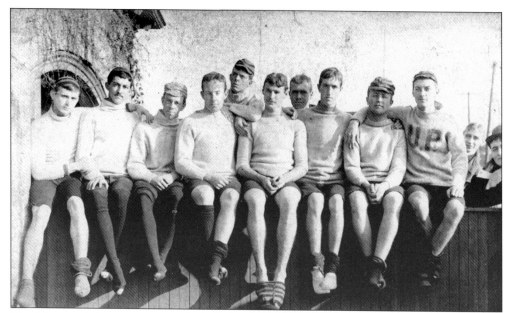

The history of Penn crew stretches all the way back to 1854, when the University Barge Club was founded. The club admitted members who were not students, however, so it was 22 years before the College Boat Club of the University of Pennsylvania organized crews consisting exclusively of students. Penn entered into intercollegiate competition in 1879. The students in this photograph rowed crew in 1890.

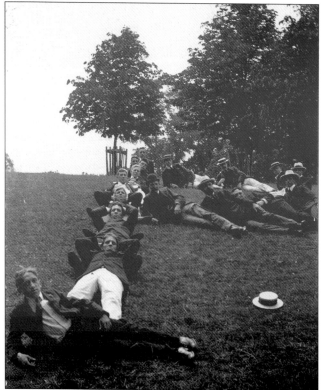

In 1901, the varsity eight traveled to England to compete in the Henley Regatta. Their transatlantic voyage took 11 days, and during the crossing, they trained on rowing machines installed on deck. They defeated the London and Thames Rowing Clubs in trial heats before losing in the final. In this photograph, the students, along with their coach and managers, demonstrate their Penn spirit in a relaxed moment.

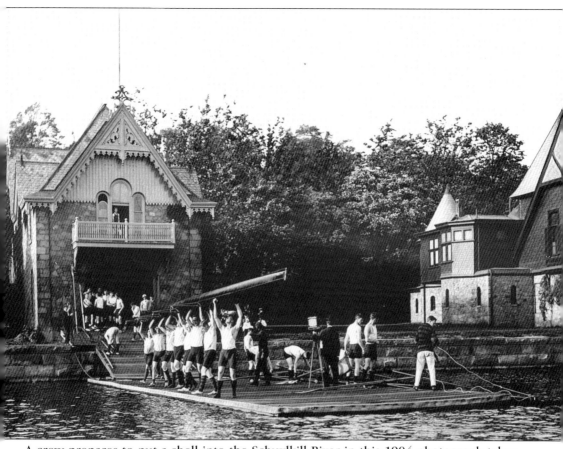

A crew prepares to put a shell into the Schuylkill River in this 1904 photograph taken from the water. In the background is the university's boathouse, which is still in existence as one of the oldest boathouses on the Schuylkill, although it has been expanded with additions on both sides. It was built *c.* 1875 under the auspices of the College Boat Club. In 1909, Edward R. Bushnell wrote in *The History of Athletics at the University of Pennsylvania, Vol. II*, "The location of the boat house, fully three-quarters of an hour's journey from the University, adds to the difficulty of developing first-class crews. Were the boat house and the course adjoining Franklin Field it is safe to say that the number of candidates would be double what it has been."

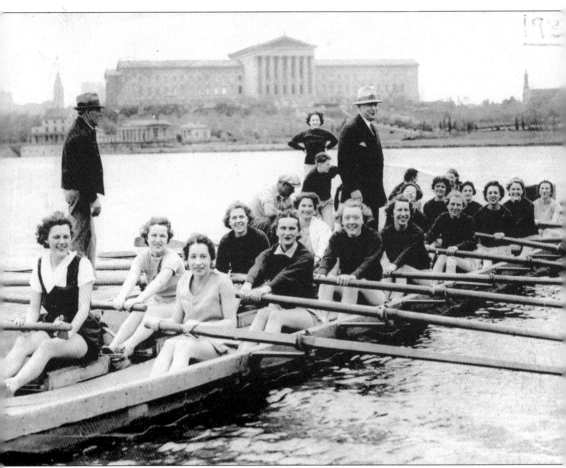

Female students first rowed in the physical education program in April 1935. In an *Evening Bulletin* article entitled "Penn Girls Enjoy Crew Work; Look Natty in Shorts," Helen Mankin reported, "Twenty-five co-eds in blue gabardine suits, red sweatshirts, sneakers and bare limbs turned out in the first group at 10 o'clock at the College Boat House along Boat House Row in Fairmount Park, followed by another squad an hour later. Close to 60 girls have signed up for the sport." Dr. Marion Rea, medical director for women's physical education, accompanied the students as a chaperone. The women rowed in groups of 16 in the "big barge," a training vessel designed for stability rather than speed. After the first day, men's coach "Rusty" Callow told the press, "The girls show lots of zest and row better than boys when they begin."

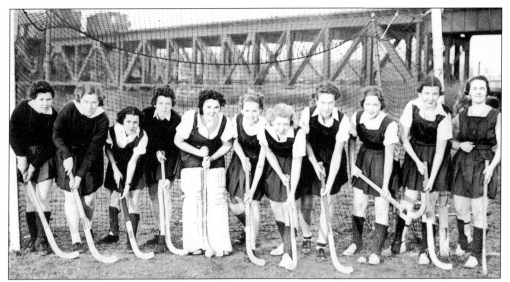

On the first day that women rowed, Dr. Marion Rea told the press, "We are considering the idea of playing friendly games with nearby colleges" in women's field hockey and basketball. The Women's Athletic Association was founded in 1921, but after 1926, women's sports shifted from intercollegiate to intramural competition for nearly a decade. This photograph of November 1935 shows the women's field hockey team after a victory over Penn's neighbor, the Drexel Institute of Art, Science, and Industry.

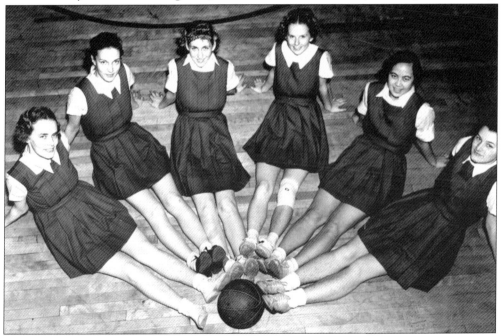

This photograph of players from the 1938 women's basketball team was likely taken in the women's gym on the top floor of Bennett Hall. The women's yearbook for 1939 described a season of four home and two away games and added that "the inconvenience of out-of-town games was more than compensated by the graciousness of the opponent-hostesses who held teas for the Pennsylvania women after the games."

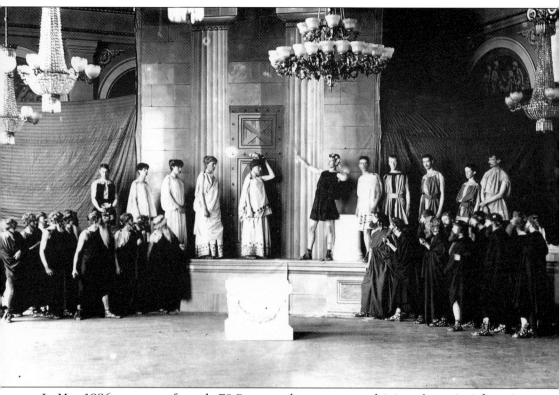

In May 1886, a group of nearly 70 Penn students presented Aristophanes's *Acharnians* in ancient Greek at Philadelphia's Academy of Music. An audience of nearly 3,000 turned out for the performance. A New York performance took place in Carnegie Hall in the fall, and the *Evening Telegram* noted that the Penn students "talked . . . what most of their auditors accepted to be Greek on faith." The committee presenting the play sold copies of the libretto in Greek with a facing translation in English. After the Philadelphia performance, *Taggart's Sunday Times* reported, "The Greek play . . . by the University boys created quite a flutter in high-toned circles last week. The aesthetic young ladies wildly cheered the stalwart students, who appeared in scant Grecian costumes, with real bare legs, hosiery being ignored as inconsistent with a real Greek play."

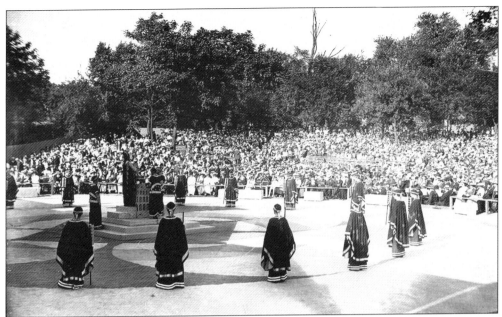

In June 1915, a theater company presented *Iphigenia in Tauris* in English in the university's Botanical Gardens. Approximately 6,000 spectators attended, as seen from the stage in the above photograph. A few students participated as walk-ons. The huge shepherd in the photograph below is Mike Dorizas, a graduate student and Olympic athlete who later joined the Wharton faculty. William N. Bates, a professor of Greek, gave the production this mixed review in *Old Penn*: "When Iphigenia entered . . . in a bright red dress of archaic style students of Greek were surprised; and when the chorus consisting of twenty-one members (not fifteen as required by Greek convention) and wearing an impossible costume put in its appearance it at once became evident that . . . the play could not be judged according to ancient standards."

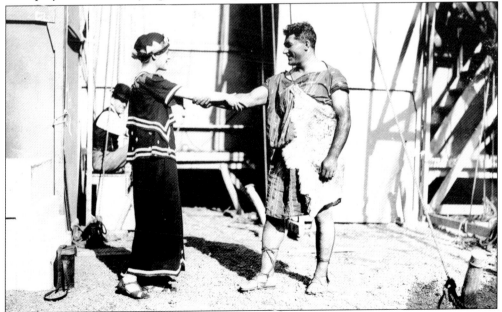

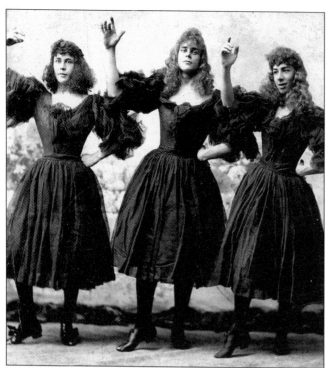

In 1888, a group led by College student Clayton F. McMichael founded the Mask and Wig Club, an all-male musical comedy troupe. This photograph shows a trio of cast members of *Lurline,* the club's first production, presented at the Chestnut Street Opera House in June 1889. The 1890 yearbook predicted for the club "a brilliant future—a future full of honor to itself and fame to Good Old Penn."

Mask and Wig's 1932 production was titled *Ruff Neck.* Between 1925 and 1932, each Mask and Wig comedy had a two-week run. The extensive schedule of performances was scaled back in succeeding years due to the effects of the Great Depression. Here, university administrators greet the cast. In the center, from left to right, are Pres. Thomas S. Gates, Queen Elizabeth (played by a Wharton student, James B. Glading), and Provost Josiah H. Penniman.

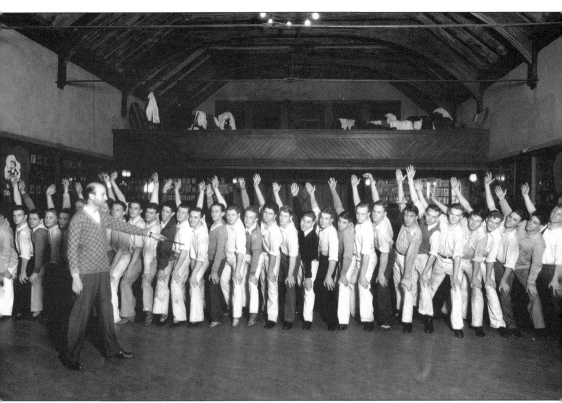

If the coach of this Mask and Wig rehearsal is Charles Morgan, then this photograph was taken *c.* 1930, when Morgan retired from active participation in the shows. As a Wharton student, he was involved in the 1895 production. As an alumnus, he continued to participate as an actor, writer, director, and dance coach for 35 years. In an article in the *North American* in 1916, he said of the chorus, "They have to learn the steps just as we all learned the multiplication table, so that they become unforgettable and can be done absolutely without thought." The students in the left half of the line are learning their steps in women's heeled dancing shoes. The setting of the photograph is the Mask and Wig Club House at 310 South Quince Street, purchased by the club in 1893.

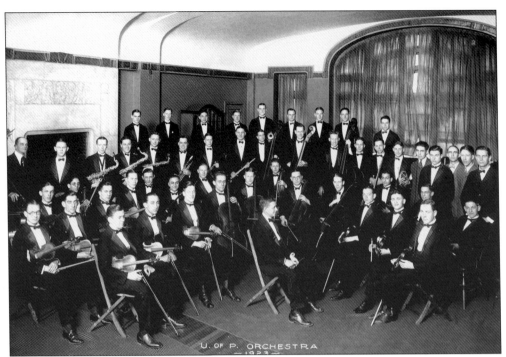

Penn's orchestra began in 1887, but in its early decades, it had little presence on campus. The Glee Club and the Banjo and Mandolin Clubs originally had more support from students, perhaps because, as the 1889 yearbook lamented, "It seemed at first as if nearly every instrumentalist in college played the same instrument." By the fall of 1922, when Penn's musical clubs reorganized, the orchestra had 80 members.

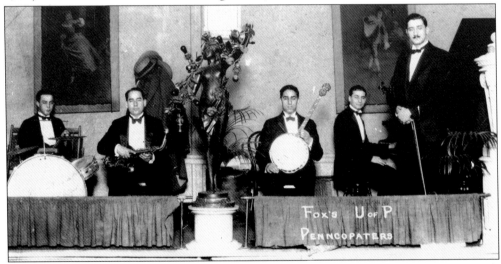

This photograph of the Penncopaters was likely taken in 1928 or 1929. Both professional and student bands performed at "smokers," social events that took place in Houston Hall (although that is not the setting of this photograph). In the student newspaper, organizers of smokers promised "high caliber acts, smokes, and refreshments." The program usually included a speaker and a band. Other possibilities included film reels (with musical accompaniment by the bands) or vaudeville acts.

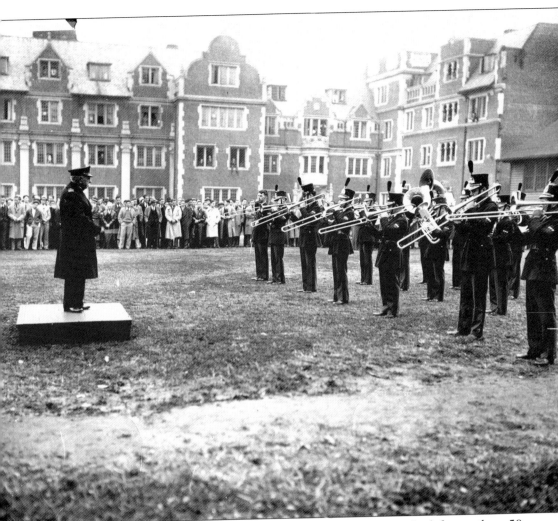

Penn's marching band started in 1897. In its early decades, it had fewer than 50 members. The band contributed music to commencement, University Day, and athletic events. In this photograph, John Philip Sousa conducts the 125 students of the band in the Quad during his third visit to campus, in November 1930. Harry A. Mackey, mayor of Philadelphia and alumnus of the Law School, declared the day of the visit "Sousa Day" and attended the performance. After leading the band in a rendition of "The Stars and Stripes Forever," Sousa commented to the *Pennsylvanian*, "It has been my privilege to lead many college bands, and the one I led this afternoon ranks with the best of them. The University should be proud of this organization. It is really fine."

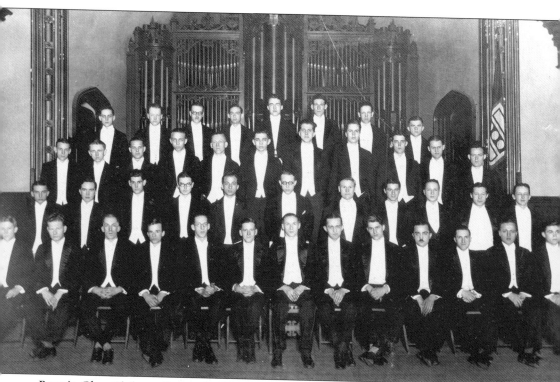

Penn's Glee Club attributes its founding to eight students in 1862, making the club older than the West Philadelphia campus. This photograph of the Glee Club was distributed in 1928 as publicity for a CBS radio broadcast of a concert in Irvine Auditorium. The *Pennsylvanian* exulted, "This broadcast will carry the songs of Pennsylvania across nearly the entire continent, reaching as far west as Nebraska, and it is estimated that about eight million listeners will hear this special program." The Glee Club was larger than it had ever been, with 150 voices, and this concert was its first appearance in Irvine Auditorium, which had been completed earlier that same year. The radio concert was not the group's first experience with national exposure; in 1926, the club sang at the White House for Pres. Calvin Coolidge.

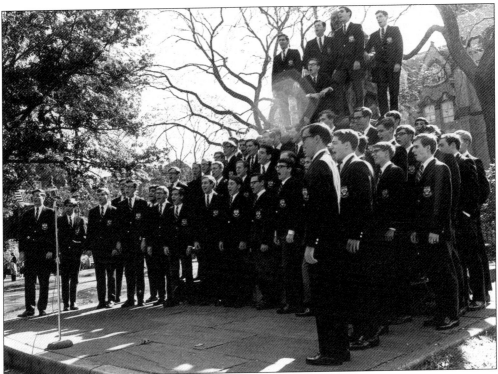

This late 1960s photograph shows the Glee Club singing at home, with Benjamin Franklin adopted as an honorary member. By this time, Bruce Montgomery had been director of the Glee Club for approximately a decade, a position he held until 2000. One highlight of the 1960s for the Glee Club was the initiation of an annual award of merit. Composer Randall Thompson received the first award in 1964.

Here, a group of students sings Christmas carols in 1987 on the sculpture *Split Button* by Claes Oldenburg and Coosje Van Bruggen. *Split Button* was installed in front of the Van Pelt Library in June 1981. Although alumni and staff wrote letters criticizing the sculpture, it has become—in addition to a stage for performers—a meeting place for students, a canvas for political statements, and a playground for children.

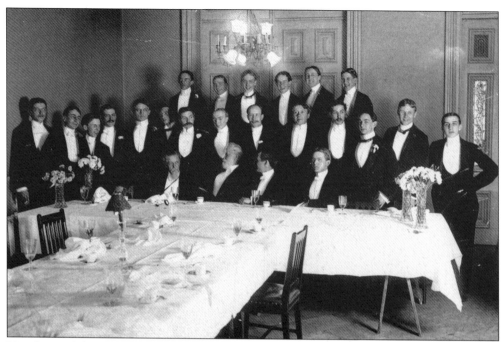

Members of the dental fraternity Psi Omega dine at a restaurant at 15th and Chestnut Streets in 1898 or 1899. At the time of the photograph, it was believed to be the first image taken at Penn "by flashlight"—with a flash. Matthew Cryer, assistant professor of oral surgery and faculty member of Psi Omega, made the powder for the flash and took the photograph.

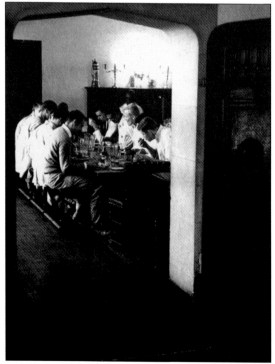

The first fraternities at Penn were established c. 1850, when Penn was still at its second campus. The students dining together in this photograph from the 1950s are members of Phi Gamma Delta, which was established in 1881 and re-established in 1890. This rare informal photograph was taken in the fraternity house on Locust Street (now Locust Walk), which the fraternity built in 1914.

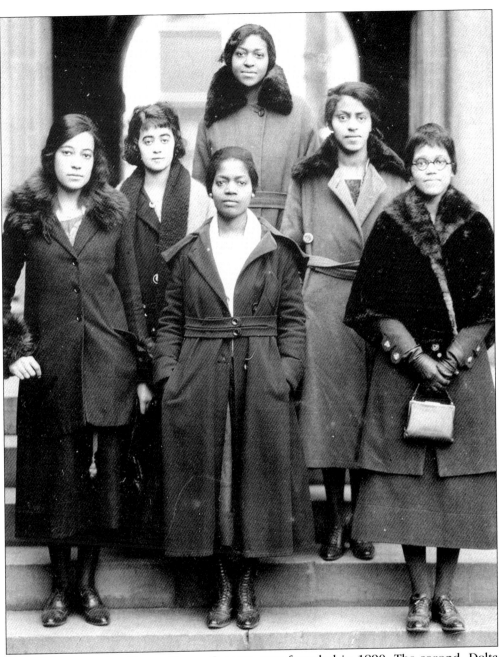

Penn's first sorority, Kappa Kappa Gamma, was founded in 1890. The second, Delta Delta Delta, was established in 1904. The Gamma chapter of Delta Sigma Theta, the first sorority at Penn whose members were African American students, was founded in 1918. The charter members were Sadie Mossell, Virginia Alexander (sister of Mossell's future husband), Esther Butler, Julia Polk, and Pauline Young. All were undergraduates in the School of Education. In December 1921, the Gamma chapter hosted the third national convention of Delta Sigma Theta at Penn. The Penn "sorors" at the convention, from left to right, were as follows: (first row) Alexander, Polk, and Mossell; (second row) Anna Johnson and Young; (third row) Nellie Bright.

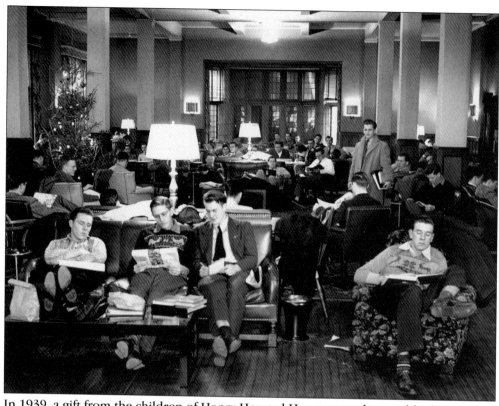

In 1939, a gift from the children of Henry Howard Houston made possible the addition of two wings to Houston Hall's 1896 building. The 1951–1952 *Announcement* noted, "On the first floor of the west wing is situated a large lounge where students may read and enjoy quiet relaxation." This photograph shows the lounge at the end of the fall semester, likely in the early 1950s.

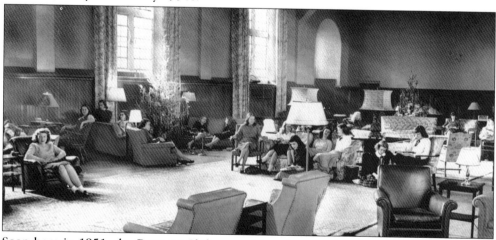

Seen here in 1951, the Bennett Club, a social and recreational center for the women students, had replaced the women's gym on the fourth floor of Bennett Hall during the 1945–1946 school year. As in the previous photograph, Christmas decorations are in evidence. The club provided a space for large events such as musicales, lectures, and dances, as well as a comfortable setting for female students during their free time.

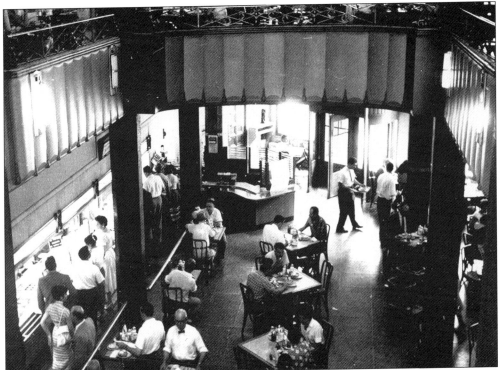

The 1958–1959 freshman handbook carried an advertisement for Horn & Hardart, promising, "You will have the pleasure . . . of enjoying fine, fresh food such as you are accustomed to having at home." The cafeteria stood at 34th and Walnut Streets for approximately 30 years. This photograph was taken on its last day of business, June 28, 1959. It was closed and demolished to make way for the Van Pelt Library.

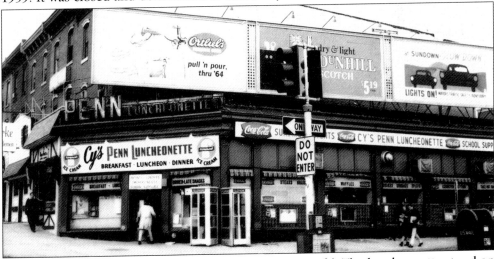

Cy's Penn Luncheonette is pictured here in February 1964. The luncheonette stood on the northwest corner of 34th and Walnut Streets. Students could eat breakfast, lunch, dinner, or ice cream, either at the counter or in booths. The luncheonette also sold school supplies, smoker's supplies, and magazines. Known affectionately as "The Dirty Drug," its popularity surged after Horn & Hardart closed across the street.

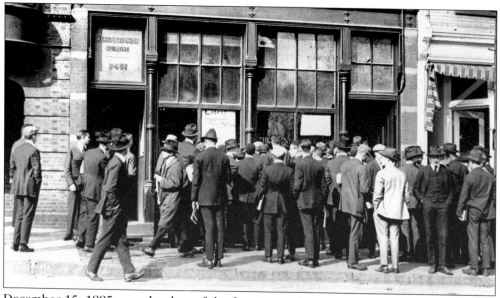

December 15, 1885, was the date of the first issue of the student newspaper, originally a weekly entitled the *Pennsylvanian.* Its editors pleaded for students to subscribe and stated, "The *Pennsylvanian* begins its career under the most favorable auspices, and we feel justified in predicting for it long life and prosperity." In this 1917 photograph, students gather around the newspaper's office on Woodland Avenue to await election returns.

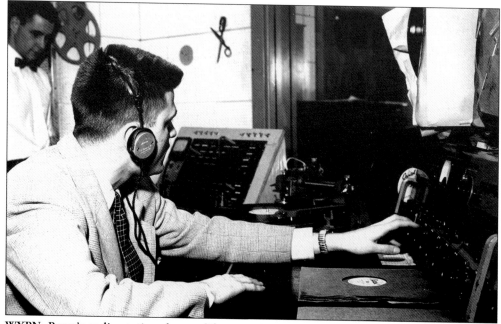

WXPN, Penn's radio station, began life as an AM station in 1945, broadcasting from the third floor of Houston Hall. In the spring of 1957, WXPN-FM went on the air and had the ability to reach listeners 7 to 10 miles away. Programming included news, sports, and music (at first mostly classical). This photograph from the late 1950s or early 1960s shows a student disc jockey at work.

Four

INNOVATION AND SERVICE

THE UNIVERSITY

AND THE WIDER WORLD

*The Idea of what is true Merit, should also be often
presented to Youth . . . as consisting in an Inclination join'd with
an Ability to serve Mankind, one's Country, Friends and Family;
which Ability is . . . to be acquir'd or greatly encreas'd by true Learning;
and should indeed be the great Aim and End of all Learning.*

—Benjamin Franklin, 1749

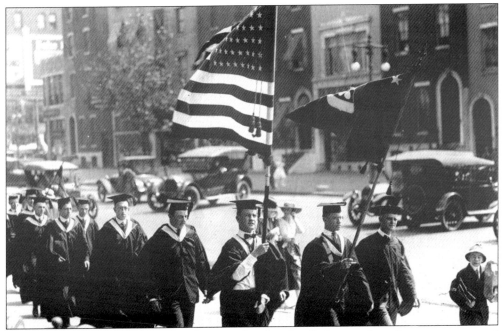

The display of the American flag at the head of the students' commencement procession in 1917 seems to have been a new addition due to the patriotic fervor of World War I. Throughout its history, Penn both influenced and was influenced by wider intellectual, social, and political developments.

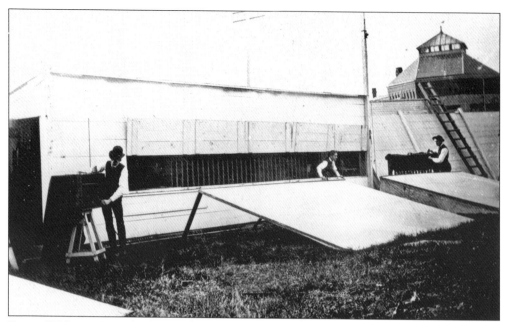

From 1883 to 1887, the history of Penn intersected with the history of photography. The university invited Eadweard Muybridge, who had begun to experiment with photographing animals in motion in California, to continue his work in Philadelphia. This photograph shows the outdoor studio that Muybridge set up at 36th and Pine Streets, south of the hospital. The building behind the studio on the right is the School of Veterinary Medicine.

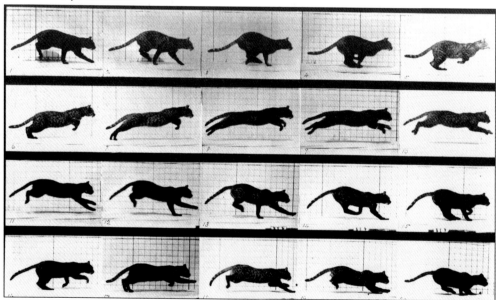

The result of Muybridge's work at Penn was *Animal Locomotion,* a collection of 781 plates of motion studies of a large variety of animals, including humans. His human models included hospital patients, students, and the dean of the veterinary school. Muybridge's method of using a battery of 24 cameras to take photographs in succession produced plates such as this one of a cat in motion.

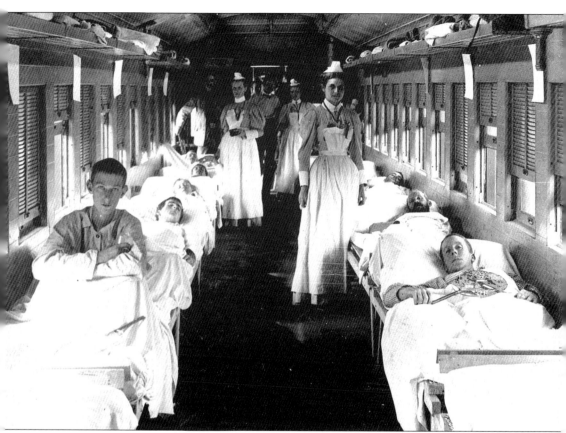

This photograph shows one of the six hospital trains that Penn staffed and equipped at its own expense during the Spanish-American War. As George W. Corner explains in *Two Centuries of Medicine: A History of the School of Medicine, University of Pennsylvania,* "The Army was unprepared for campaigns in the tropics and suffered greater losses from infectious diseases, chiefly typhoid fever, than from the enemy's fire. The number of typhoid cases in the camps in Florida and along the Gulf coast overtaxed the military hospitals. Hundreds of ill soldiers had to be brought north to civilian institutions. . . . [Penn's trains] transported patients from Atlanta, Knoxville, Washington, Camp Meade (near Baltimore) and the port of New York. The University Hospital admitted 267 soldiers, of whom 145 had typhoid fever. That only five of these typhoid patients died was evidence of expert medical care and nursing."

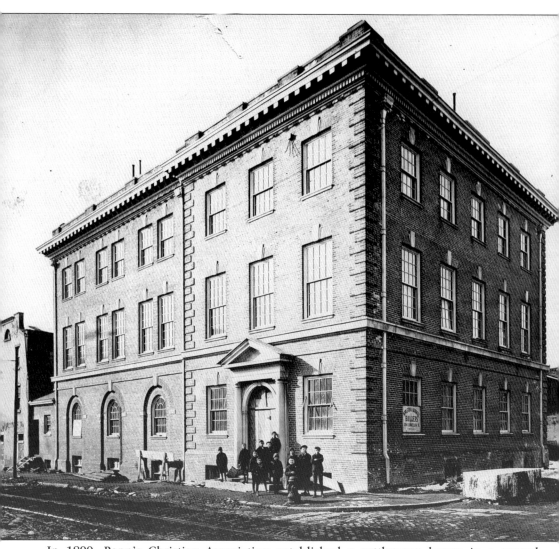

In 1899, Penn's Christian Association established a settlement house in a rented building across the Schuylkill River. At the house, Penn students helped offer education and recreation programs to children and adults living in that neighborhood. This photograph shows the new settlement house at 20th and Lombard Streets shortly before its opening in 1906. It included living quarters for five full-time staff members and up to 10 students. According to the November 2, 1907, issue of *Old Penn*, "The neighborhood in which it is located consists of working people, and one of the chief objects of the Settlement is to bring the students of the University into touch with them, in order that the students may understand their problems and be able to deal with such problems intelligently in the communities where these same students will be after graduation."

One of Penn's earliest windows to a wider world was through the expeditions of the University Museum. In 1888, the university sponsored a Babylonian expedition to Nippur, in modern Iraq. Members of the Department of Archaeology were soon also involved in archaeological work in Egypt, Crete, the Yucatan, and Alaska. The Egyptian Section of the University Museum is pictured here in the early 1900s.

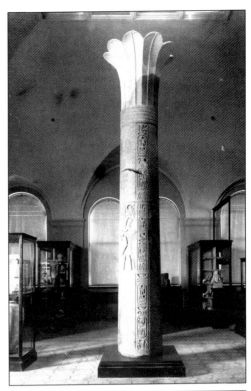

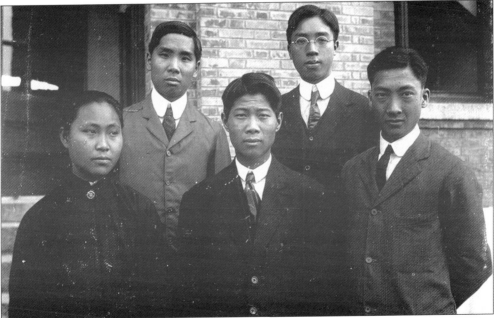

For seven years, the Christian Association operated a medical school in Canton, China, affiliated with Canton Christian College. This 1911 photograph shows the first class of the University Medical School. The school's annual report for 1912 states that at the beginning of the class's third year, the woman and two of the men passed examinations to allow them to study in the United States.

Students enlist for service with the university's Base Hospital No. 20 in June 1917. Of the 153 enlisted men of the unit, one-third, including the seven officers, were students or alumni. *A History of Base Hospital No. 20* stated in 1920, "All the enlisted men chosen possessed exceptional ability. They were all volunteers and sought service . . . as offering them the quickest means of reaching France."

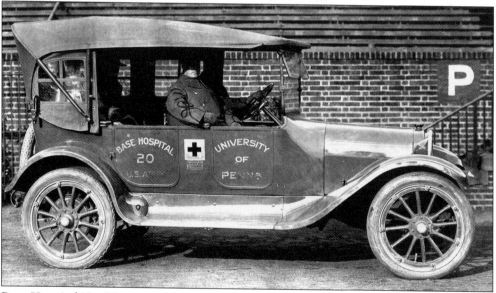

Base Hospital No. 20 was equipped to establish a 500-bed hospital wherever necessary. Its equipment included three ambulances, one of which was purchased entirely with funds donated by the Mask and Wig Club. The hospital unit donated two other ambulances to different military organizations when the United States government limited each base hospital to three. This ambulance was photographed in Franklin Field in 1918, before the unit left for France.

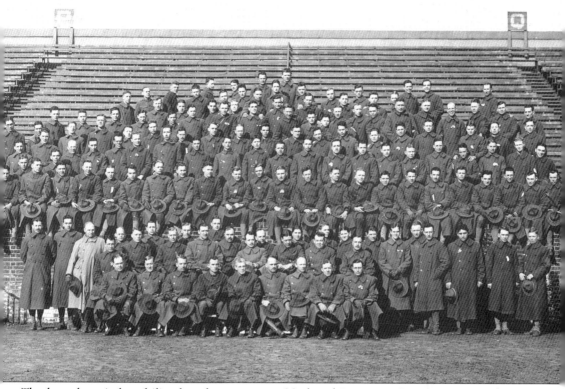

The base hospital mobilized at the armory at 33rd and Lancaster Streets in November 1917. Penn allowed the unit to use Franklin Field, Weightman Hall, and the White Training House north of Weightman Hall. This photograph of the officers and men of Base Hospital No. 20 was taken in Franklin Field on March 26, 1918, during a field meet pitting platoons against each other. As the meet was concluding, a telegram arrived with instructions for departure. The unit shipped out on April 1, 1918. After three weeks at Camp Merritt, New Jersey, its members traveled to the French town of Châtel Guyon. Base Hospital No. 20 opened at the Hôtel du Parc on May 30, 1918. Many additional buildings were gradually taken over to house more patients—8,703 in all before the hospital closed in January 1919.

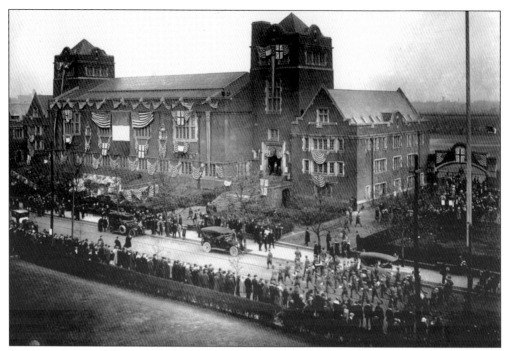

In May 1917, a delegation of French military officers including Joseph Joffre, former commander in chief on the Western Front, and René Viviani, former French premier, visited Penn as part of a trip to the United States. Provost Edgar Fahs Smith conferred the honorary degree of doctor of laws on both Joffre and Viviani at the foot of the statue of the young Benjamin Franklin in front of Weightman Hall.

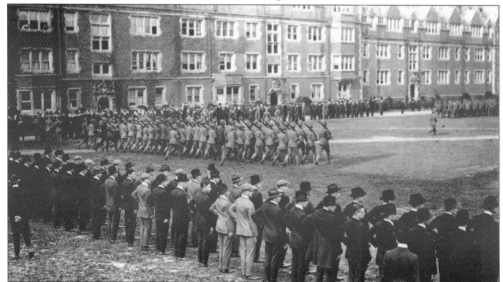

During the 1916–1917 school year, before the United States had entered World War I, the university established a military training course. Maj. William Kelly enumerated the lack of facilities for training in the January 19, 1917, issue of *Old Penn,* noting, "Whenever weather has permitted, drills . . . have been held on Hamilton Walk and in the quadrangle and walks of the dormitories, both rather restricted spaces for the purpose."

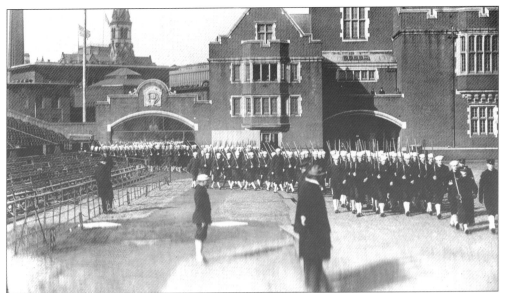

The U.S. War Department established the Student Army Training Corps (SATC) in September 1918. Penn's quota was 5,000 in the general SATC and 500 assigned to the Naval Unit. Incessant drilling took place on Franklin Field in an attempt to train large numbers of students. In this photograph from November 1918, the Naval Unit marches onto Franklin Field for review.

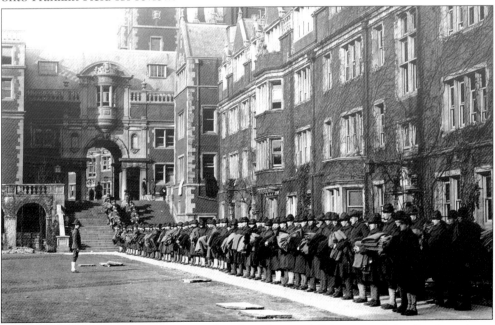

The war came to an end two months after the establishment of the Student Army Training Corps, and demobilization orders followed soon after. This photograph shows the demobilization at Penn in December 1919. The university, having lost many of its pre-war students to military service, now faced the challenges of demilitarizing the campus and losing many of the 3,000 SATC students whose plans for civilian life did not include further studies.

Lightner Witmer, seen here in 1912, was an undergraduate at Penn in the 1880s. After graduate work in psychology at Penn and the University of Leipzig, he returned to Penn as an instructor in experimental psychology. Wanting to make psychology more applicable, he established the first psychological clinic in the world in 1896. At the Penn clinic, Witmer and his students evaluated and treated children and adolescents.

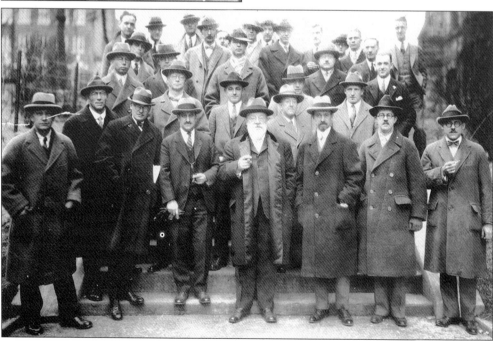

Experimental psychologists from universities including Penn, Cornell, Harvard, Yale, Columbia, Princeton, the University of Chicago, the University of California, and the University of Michigan met at Penn for three days in April 1926 to report on and discuss their research. *Old Penn* noted, "Although the University of Pennsylvania has long had a world-wide reputation for its work in Clinical Psychology, the field of Experimental Psychology has not been neglected."

In 1940, Penn celebrated its bicentennial. A week-long celebration just before the beginning of the school year included a convocation at which Pres. Franklin Roosevelt received the honorary degree of doctor of laws. This photograph shows his arrival with Eleanor Roosevelt. Edna St. Vincent Millay, not a member of the Penn community and seemingly not a Roosevelt supporter, wrote a satirical poem about the occasion, which read in part, "The Democratic candidate for the Presidency is a Doctor of Laws,—I know because / I paid his fare / All the way to Pennsylvania—a fine big state with many monuments of note: / The Liberty Bell, for instance, and the second largest / Electoral Vote; a state / of whose State University, I should think, most any candidate / For the Presidency, if he could, / Would be pleased to wear the purple hood."

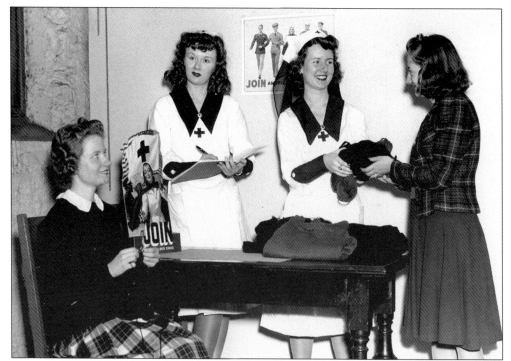

The uniformed student on the left is Jeanne Greyer, a sophomore in the College for Women when this photograph was taken in the fall of 1941. She organized the first college chapter of the Red Cross in the United States in the basement of Bennett Hall. Two-thirds of the sweaters knitted with Red Cross wool went to England; the remaining third was distributed in the United States.

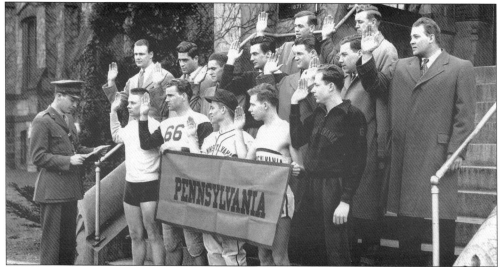

On March 25, 1942, 14 athletes from the football, basketball, baseball, crew, and track teams joined the Marine Corps. Lt. Anthony Caputo administers the oath. Before graduating from Wharton the previous spring, he had played four years each on Penn's basketball and baseball teams. This photograph appeared on the cover of the May 1942 *Pennsylvania Gazette*.

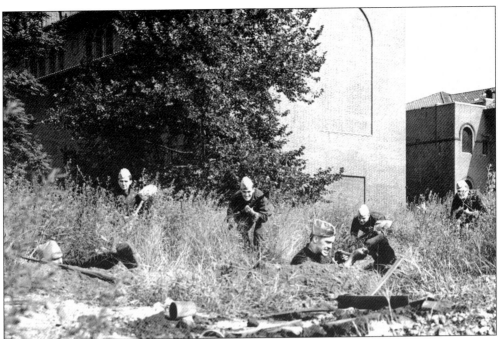

This strange scenario of ROTC students in training behind the University Museum appeared on the cover of the October 1942 *Pennsylvania Gazette*. An article inside explained, "The training of the students is in the hands of vigorous and progressive officers who are alert to the present needs. There is not as much attention paid to the old close-order drill and class room instruction as compared to the old days."

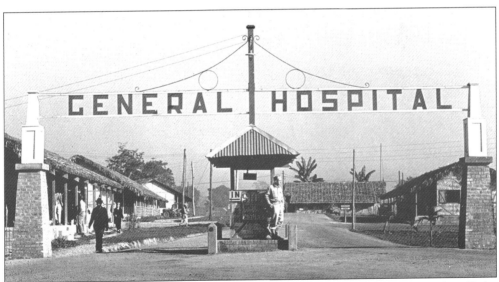

During World War II, Penn's medical school and hospital again organized and staffed a military hospital, this time in northeast India. Most of the 20th General Hospital's medical staff, nurses, and enlisted men had ties to the university. Isidor S. Ravdin, professor of surgery, led the 20th General as both executive officer and chief of the surgical service. This photograph was an illustration in the hospital's 1944 annual report.

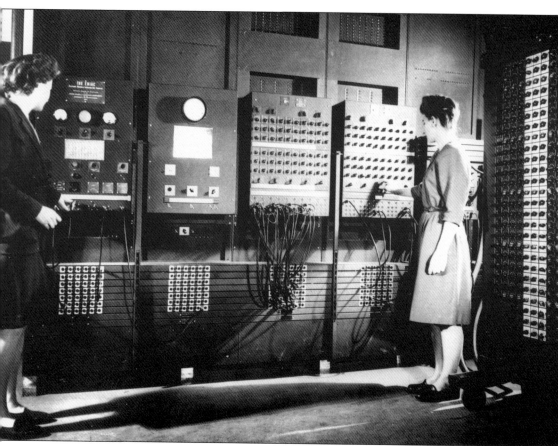

The Moore School of Electrical Engineering entered into contracts with the U.S. Army during World War II to develop the first large general-purpose electronic computer. The army needed a more rapid means of calculating complex artillery trajectories. Penn's answer to this problem was the Electronic Numerical Integrator and Calculator (ENIAC), a room-sized computer with vacuum tubes for brains. It was operational by 1945. The two members of the Penn community most closely associated with the development of the ENIAC were John W. Mauchly, professor of electrical engineering, and J. Presper Eckert, a graduate student at the Moore School. This mid-1940s photograph shows Elizabeth Jennings (left) and Frances Bilas, both programmers, standing in front of part of the ENIAC. The army sought out women to do mathematical work during the war.

On December 7, 1942, the first anniversary of the attack on Pearl Harbor, Pres. Thomas S. Gates unfurled a service flag above the main entrance to College Hall. The number 4,881 stood for the total number of students, alumni, alumnae, faculty members and administrative employees who had entered the armed forces. The number 13 represented those who had lost their lives in military service.

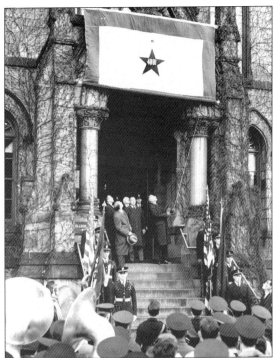

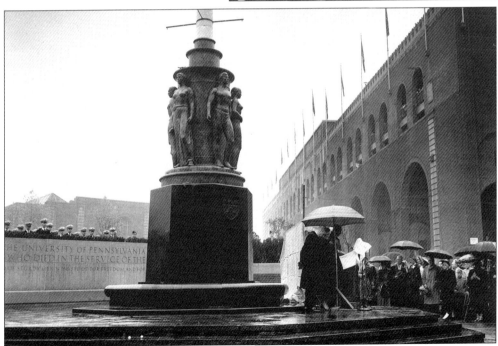

In 1952, Penn dedicated a flagpole with a statuary base and a surrounding bench as a war memorial. Its text reads, "To Her Sons Who Died in the Service of Their Country, 1740–1952." The memorial, located just north of Franklin Field on 33rd Street, was the first of many gifts of alumnus Walter H. Annenberg. The dedication took place on a rainy November Saturday before the Penn-Army football game.

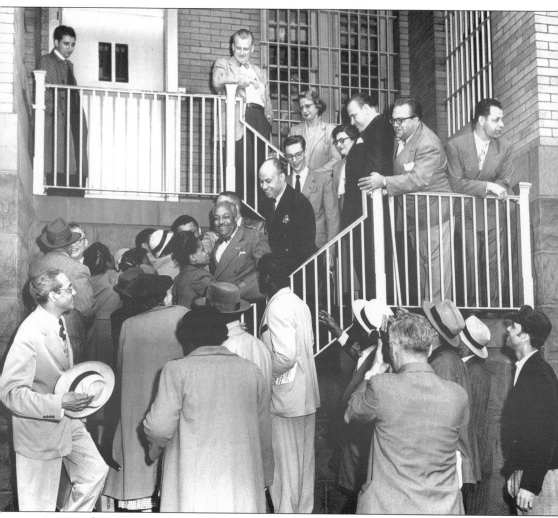

Raymond Pace Alexander graduated from the Wharton School in 1920 and Harvard Law School in 1923. He specialized in criminal law and represented parties in several civil rights cases. In 1951 and 1952, Alexander was on the team of defense lawyers in the retrial of "the Trenton Six." Here, he stands at the lower left corner, hat in hand, as a crowd greets the four men who were acquitted. Alexander married alumna Sadie Tanner Mossell in 1923, and both figured prominently in the civic life of Philadelphia. Raymond was elected to the Philadelphia City Council in 1951. In January 1959, he became the first African American to serve as a judge on the Court of Common Pleas. He continued to serve as a judge until his death in 1974.

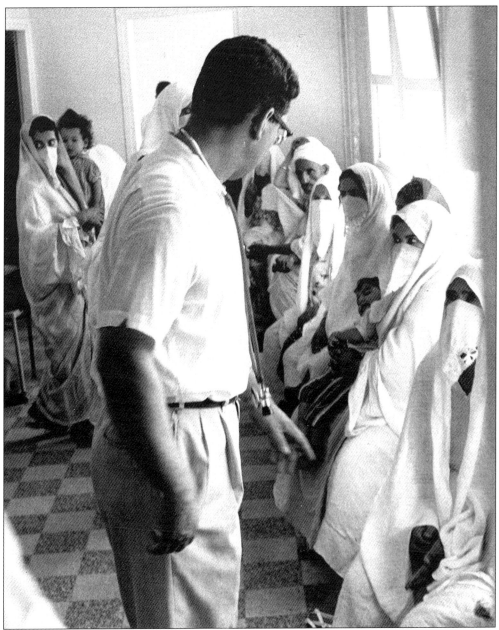

In July 1962, Algerians voted overwhelmingly for independence from France in a referendum, marking the end of the war that had begun in 1954. One month later, at the request of the Provisional Government of the Algerian Republic, a medical team of mostly Penn personnel departed for Algeria. They worked in the Beni-Messou Hospital in Algiers. Most of the hospital's French medical staff had left during and after the war. Dr. George Ludwig, associate professor at the School of Medicine, was the leader of the Penn team. In this photograph, which appeared in the *Pennsylvania Gazette* in October 1962, Dr. Ludwig speaks to women in the outpatient clinic. At the end of August, a team from another institution arrived and the Penn staff returned home.

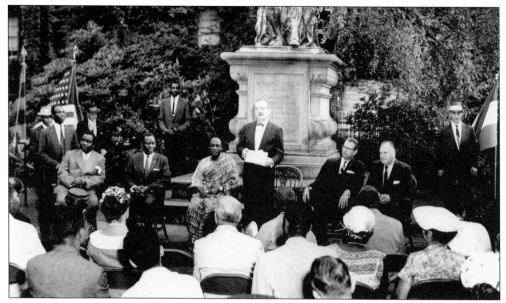

In July 1958, Kwame Nkrumah, prime minister of Ghana, visited Philadelphia. Councilman Raymond Pace Alexander served on the city's welcoming committee. Nkrumah had earned master's degrees in education and philosophy at Penn in the 1940s, and the university presented him with a citation honoring his accomplishments. Here, Nkrumah, seated center, listens to Roy Nichols, dean of the Graduate School of Arts and Sciences.

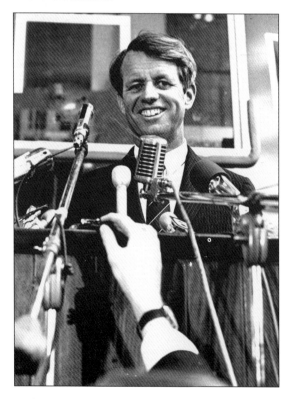

Sen. Robert F. Kennedy visited Penn in April 1968 during his presidential campaign. He spoke at the Palestra to a crowd estimated at 11,000, including approximately 1,000 listening to the speech by loudspeaker outside the building. Kennedy joked that when he was not accepted by Penn, he went to Harvard. Two months later, he was assassinated in Los Angeles on the day of the California primary.

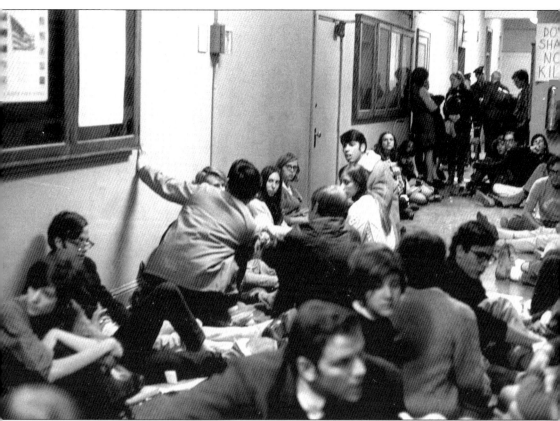

In November 1967, students opposed to the Vietnam War gathered in Logan Hall for several days to protest recruiting and interviewing by the Dow Chemical Company and the Central Intelligence Agency (CIA). Some students blocked doorways of interviewing rooms, while others demonstrated in the hallways. Other students on campus disagreed with the protesters. Arthur Letcher, director of placement, told the *Daily Pennsylvanian* that other student groups had offered their facilities as possible alternative locations for the interviews. Pres. Gaylord Harnwell attempted to reassure alumni in the January-February 1968 *Pennsylvania Gazette* by saying, "Campus protests represent a modern-day version of the classic problem of balancing freedom and order. Universities, because of their unique position in our free society, bear a special responsibility for solutions in this central problem of our time."

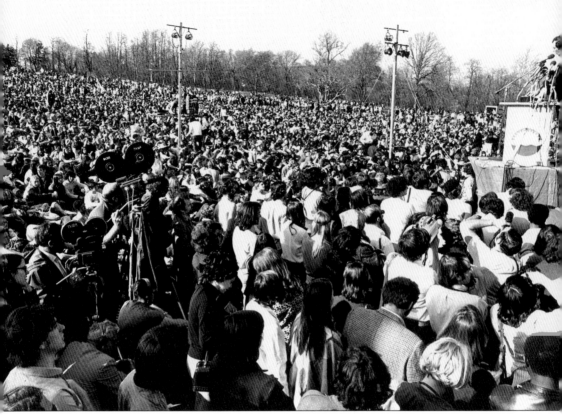

Wisconsin senator Gaylord Nelson called for a nationwide environmental teach-in on April 22, 1970. The Earth Week Committee that planned the Philadelphia response began as a group of graduate students in the Regional Planning Department in the Graduate School of Fine Arts. Student Austan Librach chaired the committee. Ian McHarg, member of the Fine Arts faculty, also served on the committee, which had office space in the Graduate School of Fine Arts. A week of speakers and exhibits culminated in the first Earth Day at Fairmount Park. The press reported that 10,000 people marched from the Philadelphia Museum of Art to Belmont Plateau, where they joined between 10,000 and 20,000 other participants. In this photograph, Edmund Muskie, a senator from Maine, addresses the crowd.

Penn has individual connections throughout the world, thanks to the many citizens of other countries who have been students here. In November 1970, International House dedicated a new building at 37th and Chestnut Streets. Although International House grew out of programs for foreign students offered by the Christian Association beginning in 1910, in April 1943 it became an independent organization.

In April 1972, students gathered at College Hall to protest a delay in approving a proposed residence for African American students in Low Rise North. Although the proposal had received preliminary approval in March, leading students to apply for residency there, final approval had stalled, leaving the applicants without leases. In the end, the Du Bois Residential Program started as planned in the fall of 1972.

The Philadelphia Zoo called on the School of Dental Medicine in the summer of 1972, when Kundar, a Siberian tiger, needed root-canal treatment. On the left is William Kemp, a teaching fellow in endodontics; on the right is Robert Burrison, the zoo's consulting dentist and a dental school alumnus. The team administers anesthesia to the tranquilized tiger.

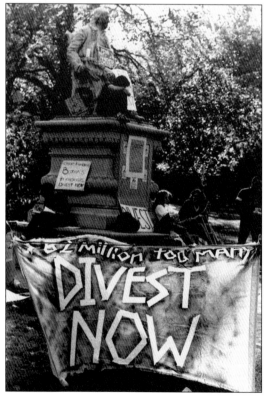

In the 1980s, the Penn community took part in the international debates on how to oppose apartheid in South Africa. One of the groups that organized student actions on campus was the Penn Anti-Apartheid Coalition, which advocated total divestment by the university. This photograph shows a student demonstration in 1985 or 1986. In January 1986, the trustees recommended a waiting period of 18 months, after which they proceeded toward divestment.

Five

CUSTOM AND CEREMONY

STUDENT TRADITIONS

AND MILESTONES

It is propos'd . . . That they have particular Habits to distinguish them from other Youth, if the Academy be in or near the Town; for this, among other Reasons, that their Behaviour may be the better observed.

—Benjamin Franklin, 1749

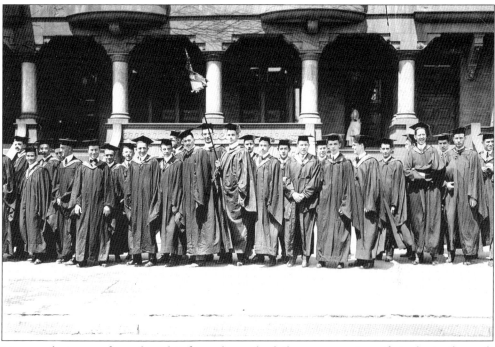

Many milestones, formal and informal, marked the progression of students through their time at Penn. Some of these traditions still thrive, while others, shared by classes over the years, are unknown to modern students. In this 1913 photograph, students gather for their commencement procession to the Metropolitan Opera House on North Broad Street.

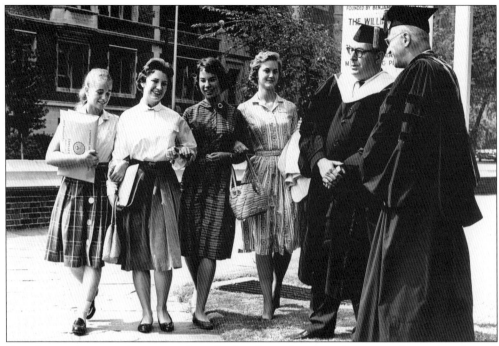

Female students arrive at Irvine Auditorium for opening exercises, the formal beginning of the school year for all students, in September 1960. To the right of the women is Provost Loren Eiseley, and on the far right is Pres. Gaylord Harnwell. Opening exercises consisted of an academic procession of the faculty, a welcome by the president, and an address to the students.

The 1913–1914 student handbook advised, "Wear your black cap; don't try to be anything else than a Freshman during your first year." By 1916–1917, the pointer had become more of a regulation: "Freshmen must wear black caps every day, except Sunday, while on the campus." This photograph shows a cap-wearing freshman of the 1950s registering for courses. Freshmen wore these caps—commonly known as "dinks"—until the mid-1960s.

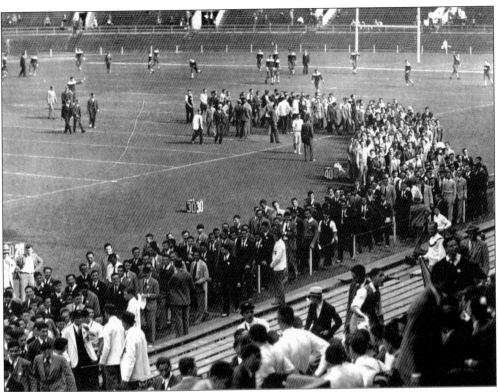

At halftime during a home game early in the season, the upperclassmen would call, "Freshmen on the field!" and the freshmen would take a walk. In this 1930s photograph, the freshmen are returning to their seats, wearing the required caps, ties, and lapel buttons. The administration brought this tradition to an end after a fight with Columbia band members on the field in the fall of 1947.

The Traditions section of the 1946–1947 student handbook declares, "All frosh must kiss the boot of Ben Franklin's statue in front of Weightman Hall during Freshman Week, after which obeisance to the founder of Penn they receive their Freshman buttons." Here, a member of the class of 1955 reaches to kiss the shoe of Franklin in front of College Hall.

Like their male counterparts, female freshmen underwent hazing of various sorts at the hands of sophomores. Beginning in 1921, women upperclassmen marked the end of the hazing period with the Pirates' Ball in October. This photograph shows some of the juniors and seniors dressed for the 1938 Pirates' Ball. The Pirates' Ball generally included skits, music, and refreshments, but no men.

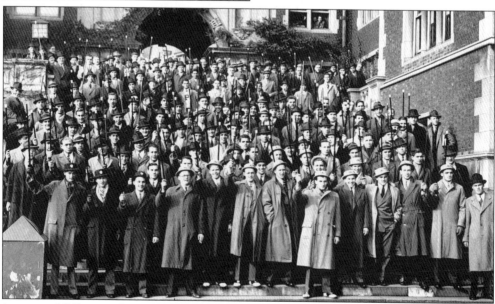

An annual fall event for the junior class was Junior Week, which started with the Cane March. Here, the class of 1937 gathers at the Junior Balcony in November 1935. The official class canes sold by the organizing committee were ebony with ivory, silver, and horn. The *Daily Pennsylvanian* proclaimed them "faultlessly correct worn with formal attire yet not too sedate to blend with street clothes."

114

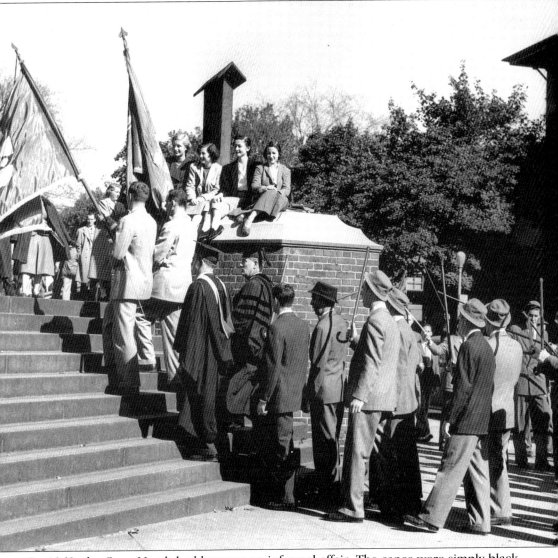

By 1949, the Cane March had become an informal affair. The canes were simply black, and students could purchase them at Houston Hall and return them for a partial refund when the event was over. The format of the march remained the same: starting from the Junior Balcony, the juniors marched through the Provost's Tower, past Houston Hall and College Hall, and down 34th Street to the Irvine Auditorium, where an all-university chapel service took place. In this photograph, women of the freshman class watch the class of 1951 entering the auditorium. The other major events of Junior Week were the Penn-Navy football game and the Junior Prom. In 1935, the prom was held in Hutchinson Gymnasium, but in the late 1940s, it was held in the Broadwood Hotel on North Broad Street.

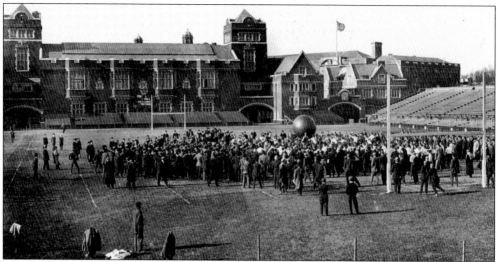

The Push Ball Fight, pictured here in 1909, first took place on Franklin Field in the fall of 1908. By one account, the Undergraduate Committee borrowed the ball from Pennsylvania State College. This competition was one of many opportunities for freshmen and sophomores to challenge each other. Each team tried to get the ball over the other team's goalpost, all the while preventing it from touching the ground.

In the 1920s, sophomores and juniors in the architecture program had an annual fight over the right of the sophomores to wear smocks in the Fine Arts Building. The sophomores would guard a smock-wearing member of their team, while the juniors would fight to tear off the smock. Students hurled eggs and mud. This photograph shows the victorious sophomores after the fight in January 1929.

"UNIVERSITY DAY"

Pennsylvania

PROGRAMME

SELECTIONS . The Municipal Band

ACADEMIC PROCESSION

PRAYER The Bishop of Pennsylvania

NATIONAL HYMN—" America "

INTRODUCTION The Provost of the University

ADDRESS The President of the United States

UNIVERSITY HYMN—" Hail ! Pennsylvania "

BENEDICTION

American Academy of Music
February twenty-second, 1898

The words of the Hymns will be found
on the other side of this Programme

Penn began to celebrate George Washington's birthday, February 22, as University Day in the 1820s. For several decades, the university honored the day with public readings of patriotic documents. Then, in 1898, as this program indicates, the University Day orator was the president of the United States, William McKinley. The occasion turned out to be one week after the explosion of the battleship *Maine* off of Havana, as momentum built toward the Spanish-American War. The University Band led a procession of students from Penn to the Academy of Music for the observances. Pres. Theodore Roosevelt and President-elect William Howard Taft gave the University Day orations of 1905 and 1909, respectively. In 1936, University Day was replaced by Founder's Day, which honored the January birthday of Benjamin Franklin and continued to provide a mid-year opportunity for alumni to return to campus.

The roots of the Bowl Fight, one of Penn's more notorious traditions, reach back to the university's second campus. This annual fight between the freshman and sophomore classes of the College then moved to West Philadelphia. The sophomores would fight first to put the freshman "bowl man" in the bowl and then to have more sophomore than freshman hands on the bowl at the end. The freshmen would fight first to keep the bowl man safe from the sophomores and then to be the class with the most men holding onto the bowl at the end. This photograph shows the sophomore guards of the bowl before the fight, likely in 1905. They are standing where the Big Quad is now, with a hospital building visible behind them.

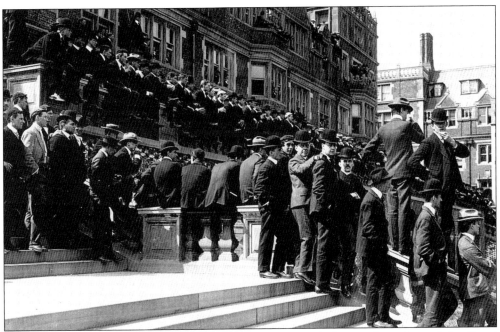

The Junior Balcony earned its name because it provided a perfect view of the Bowl Fight for the juniors. The fight took place in the open space at 36th and Spruce Streets between the Upper Quad and the University Hospital, at the future site of the Big Quad. Here, spectators congregate on the balcony for the Bowl Fight of 1902.

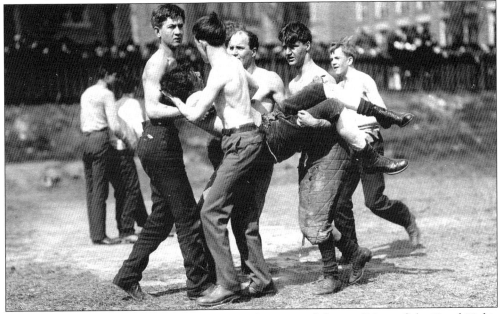

For decades, student injuries were accepted as part of the tradition of the Bowl Fight. Alumnus Edward Mumford defended the annual battle in 1906, saying, "A custom that has left treasured memories in the minds of several thousand men is not to be lightly waved aside." This 1905 photograph shows students carrying an injured classmate. After a freshman died during the 1916 Bowl Fight, the fights were finally abolished.

In March 1916, architecture students were in their first year in their new home, the former Dental Hall, and they began a new tradition of an annual Architects' Ball. They transformed the large drafting room, and *Old Penn* praised "the artistic decorations and draperies, . . . the Oriental scenes and tableaux staged by the various ateliers, and the perfect blending of all in a kaleidoscopic blaze of color, light and atmosphere."

In the spring of 1926, the theme of the annual Architects' Ball was Ball Impressionistique. Each year the architecture students tried to raise the bar a bit higher. According to the May *Pennsylvania Triangle,* the engineering and architecture magazine, the goal was "that the final result may add just a bit more to the glamour which has been characteristic of the affairs of the architects during the past years."

May Day festivities consisting of dramatic presentations by female students first took place in 1921 in the Botanical Gardens. Ninety women took part in the inaugural production, *Pan's Anniversary*. Participants dyed 400 yards of cheesecloth for the costumes. The 1921 *Women's Undergraduate Record Book* proclaimed, "We are proud of our first attempt. We know now that we women of Pennsylvania can do things—and from now on we intend to." Profits from the sale of tickets and refreshments were earmarked for the Women's Club House Fund. Later that month, the board of trustees voted to appropriate money to remodel and furnish the property at 3322 Walnut Street as a women's club called the Bennett Club. May Day continued to be a generally annual tradition, usually led by the women's dramatics honor society Bowling Green, until the late 1950s.

The tradition of the Sophomore Cremation arose in the late 19th century. In May, the sophomores would try the most unpopular members of the faculty in absentia and then burn them in effigy. The victims of 1918, from left to right, were William McClellan, dean of the Wharton School; George Chambers, professor of mathematics; and Alden Baldwin, instructor of mechanical engineering. The class of 1883 had mused in their yearbook, "A Cremation is a strange affair, all around. There is so little reason in it, and so little benefit accruing from it, either to the observers or the observed. Most college customs, though, remind us of the obstacles which the head sheep jumps over. All the others follow, without any 'why or wherefore' about it." This tradition lingered for a few more years before being relegated to the past.

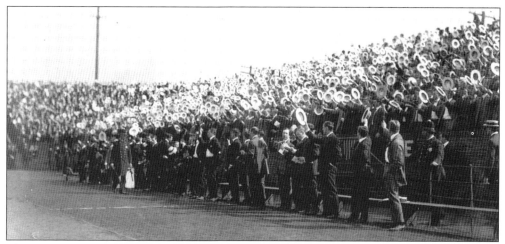

The tradition of Straw Hat Day developed early in the 20th century. The day coincided with the first Penn-Princeton game of the baseball season, always at Franklin Field on a Saturday in May. Spectators would get their straw hats out of winter storage or buy new ones. In this photograph from Straw Hat Day on May 6, 1911, some of the 12,000 spectators are singing "The Red and Blue."

A new straw hat tradition developed in the second half of the 20th century. In 1949, men wore their skimmers to the first Callow Day, a regatta and party on the Schuylkill in honor of longtime rowing coach Rusty Callow. When Callow left Penn two years later, the young tradition continued as Skimmer Day. Pictured here is the Skimmer Day crowd of 1956, a year when Penn won the Childs Cup.

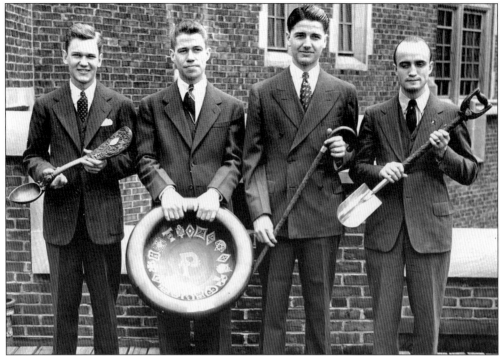

This photograph shows the award men chosen by the class of 1939. The highest honor was the Spoon Award, first given in 1865, followed by the Bowl, Cane, and Spade Awards. The Spade Award was the last to develop, first given in 1894. The four awards were part of the annual Class Day celebrations, which in 1931 merged with the newer traditions of Hey Day marking the progression of freshmen, sophomores, and juniors into the next class.

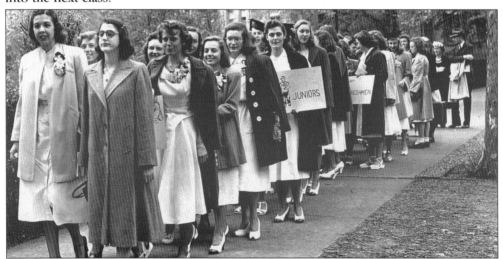

Women and men students celebrated their Ivy Day separately until 1962 and their Hey Day separately until 1968. In this May 1948 photograph, female students head from their Hey Day, held at the Christian Association, to the Ivy Day ceremonies at Bennett Hall. At Hey Day, outgoing officers transferred their authority to the incoming ones and honors were announced.

In 1873, shortly before commencement, the graduating class planted ivy and placed a tablet on College Hall commemorating the occasion. This was the inaugural Ivy Day, later associated with Class Day. In this photograph, the 1913 Spade Man, Lemuel Schofield, plants the ceremonial ivy in the Quad. The 1913 Ivy Day stone, not yet unveiled, is draped with a class pennant on the wall behind Schofield.

From 1926 to 1961, the women's senior classes placed their own Ivy Day stones, with the stones for 1926 through 1958 all located at Bennett Hall. Here, Erika Rossman (left) and Barbara Jones plant ivy for the class of 1955. Behind them, from left to right, the stones for 1955, 1950, and 1939 are partially visible. Beginning in 1962, senior men and women shared a single Ivy Day stone.

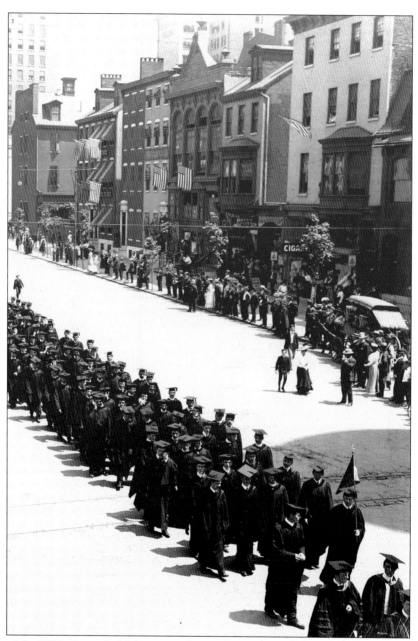

On June 12, 1901, Penn held its annual commencement at the Academy of Music on South Broad Street. The students marched from West Philadelphia for the ceremonies. Listed in the program were 554 students receiving various degrees. The most popular degree that year was the doctor of medicine, with 160 recipients; in contrast, only 27 bachelor of arts degrees were bestowed. The commencement orator was James M. Beck, a Philadelphian whom President McKinley had appointed assistant attorney general in 1900. In opening his address, he expressed his appreciation for being invited to speak, but added, "I may be permitted, however, to suggest my own doubt as to the value of commencement orations. Were they not so customary they might fall within the Constitutional prohibition of 'cruel and unusual punishment.' "

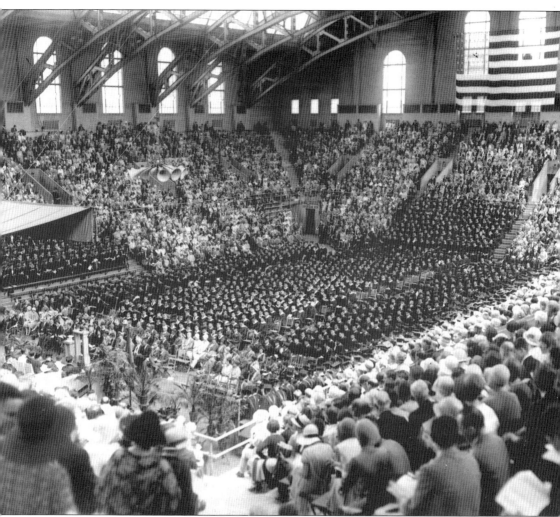

After the Palestra was dedicated in January 1927, the university held its commencement exercises there for five years. This photograph was taken at the 1930 commencement, where degrees were granted to approximately 1,660 students. Degrees awarded in 1930 that had not existed in 1901 included bachelor of science in education, bachelor of fine arts, master of architecture, bachelor of landscape architecture, and master of business administration. Cheesman A. Herrick, trustee of the university and president of Girard College, gave the Address of the Day. He noted, "It is not too much to say that the stream of manhood and womanhood which has been poured out from the University of Pennsylvania has so enriched the life of both city and commonwealth, that Philadelphia and Pennsylvania are now vastly better than they would have been without the influence of these alumni."

"Alumni Day, 1918, was observed on a strictly war basis," the *Pennsylvania Gazette* reported in its June 28 issue. Men in uniform are visible among the crowds as the classes assemble in the Big Quad. Dormitories on the south and west sides were still under construction at the time. Approximately 700 men from 20 classes ranging from 1868 to 1918 marched from the Quad to Franklin Field.

Members of the class of 1957 march in the parade on Alumni Day in 1962. Their theme was "Death of Skimmer Day." Both commencement and Alumni Day were held in May instead of June for the first time that year, in days of record heat. The preview of Alumni Day in the April *Pennsylvania Gazette* noted another change: "The parade this year will include the alumnae classes."